Far from

and other places / Dominic Greyer

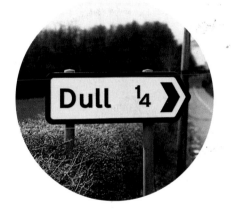

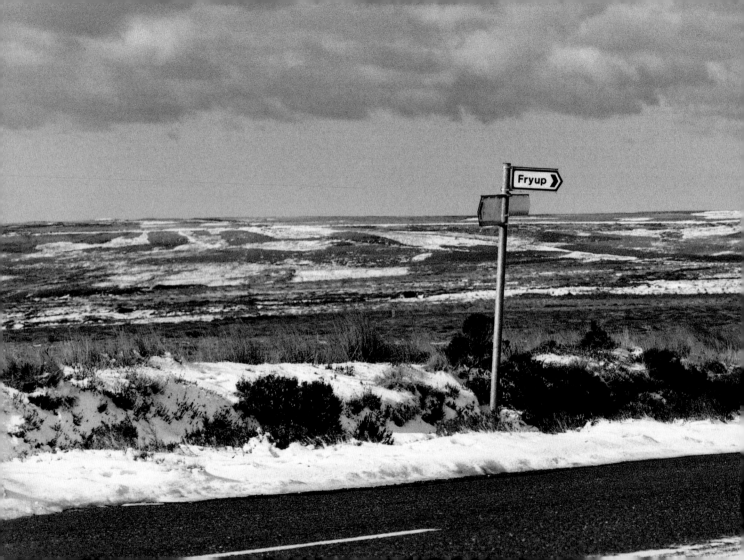

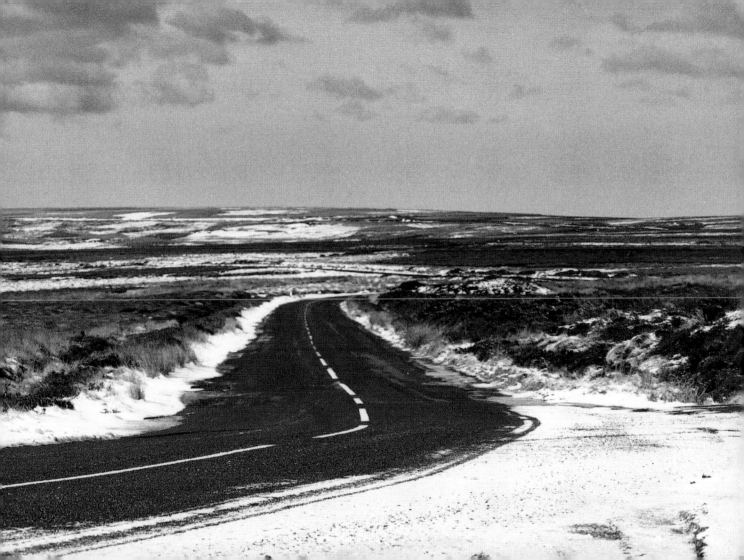

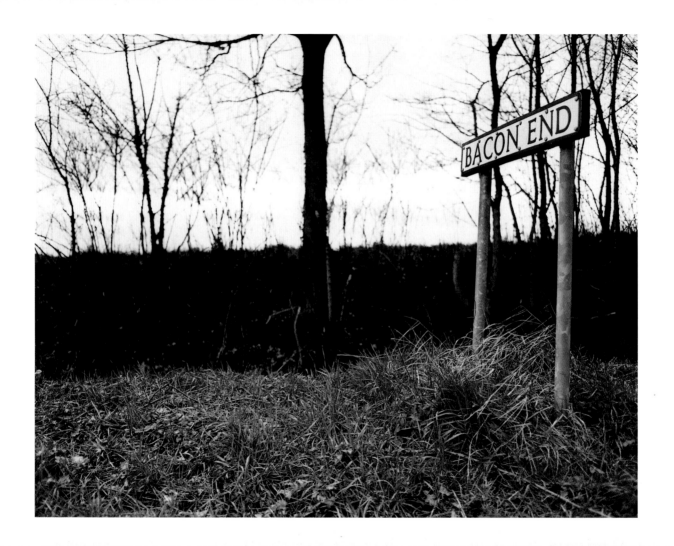

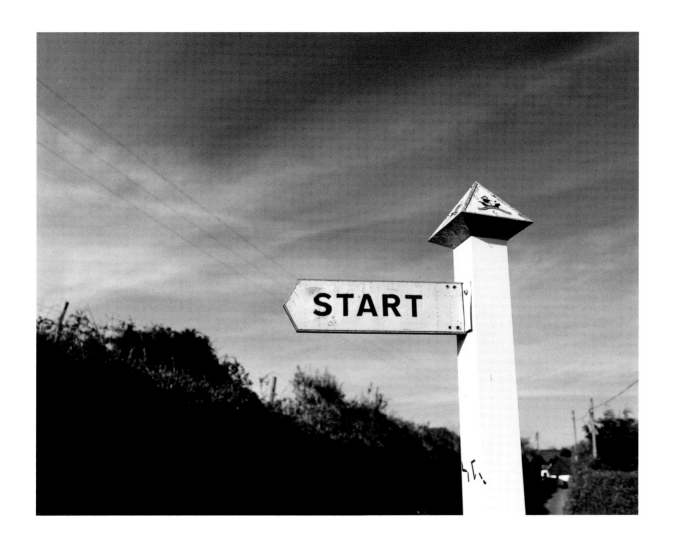

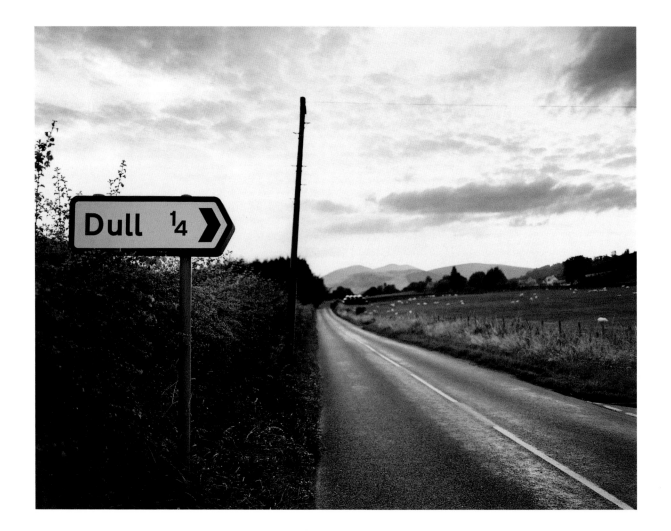

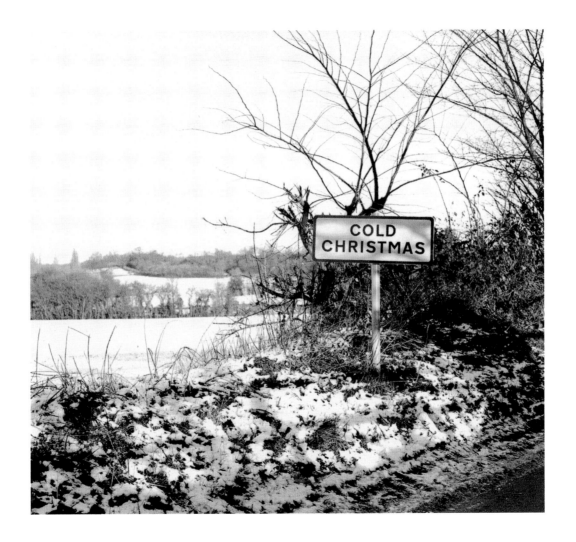

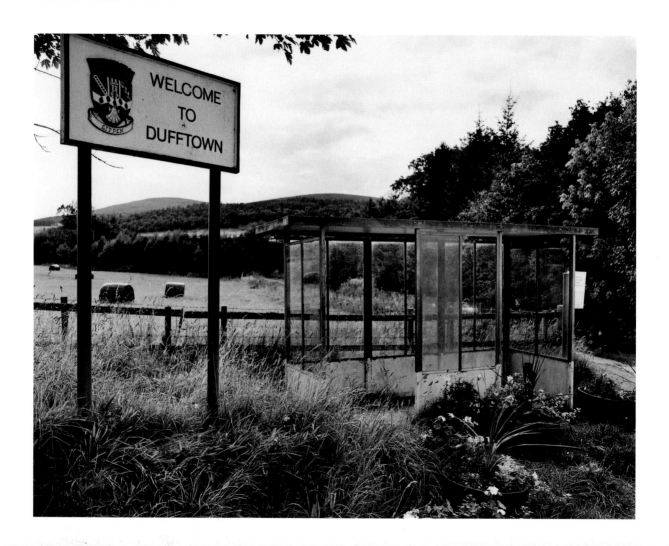

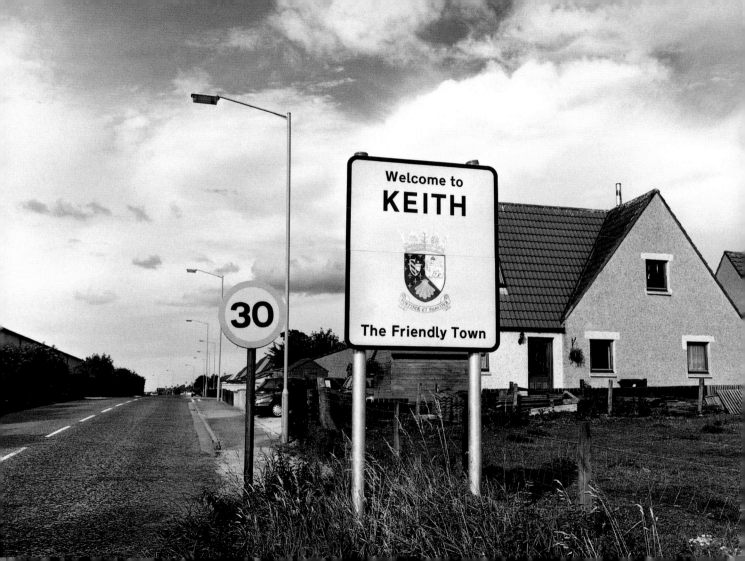

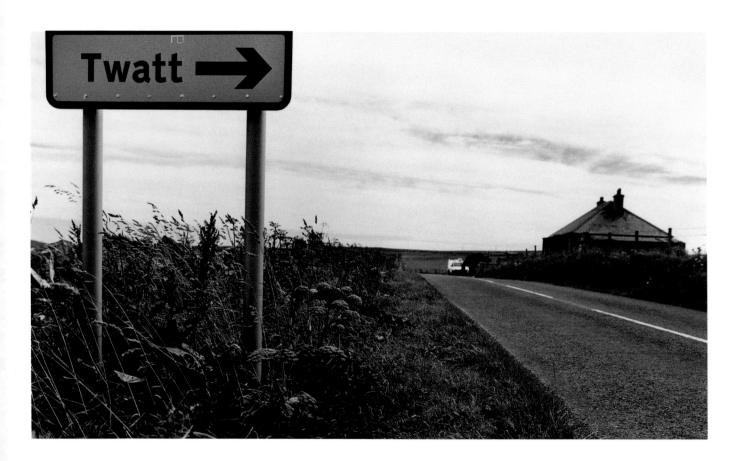

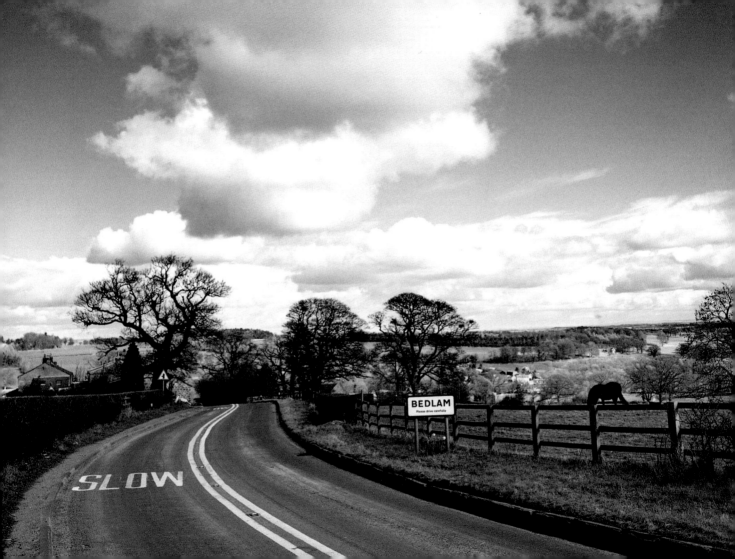

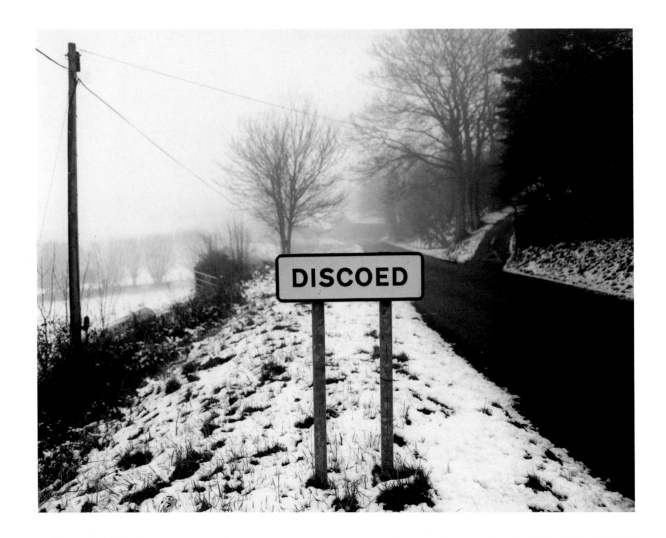

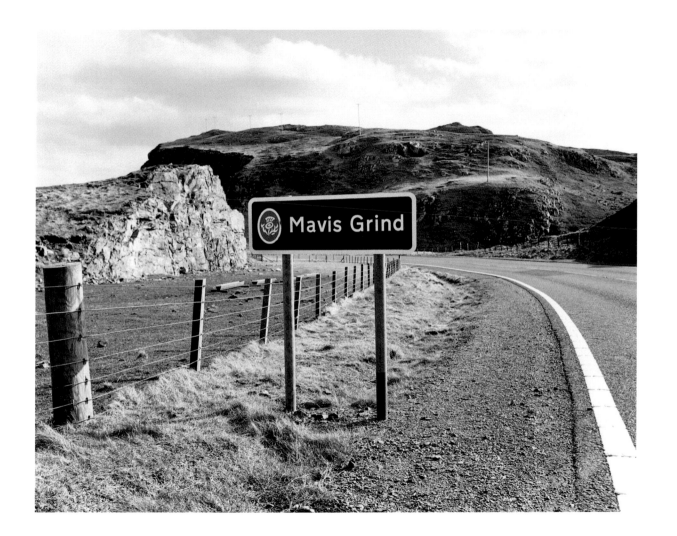

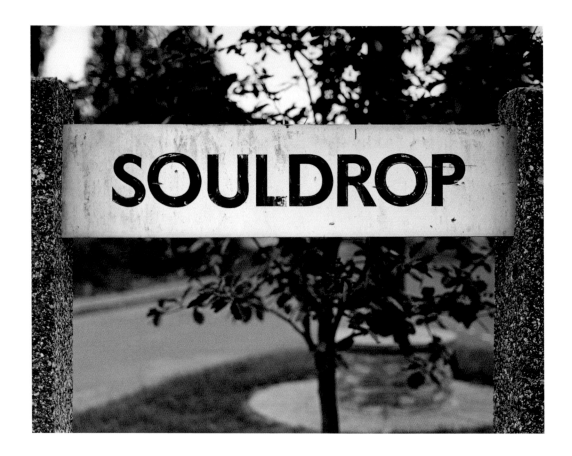

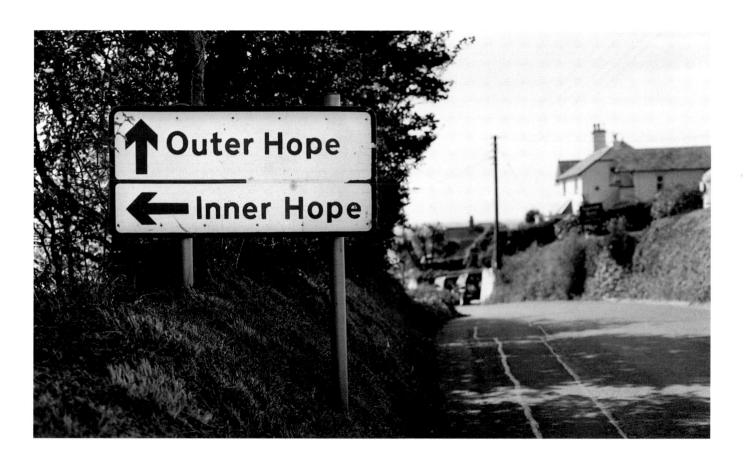

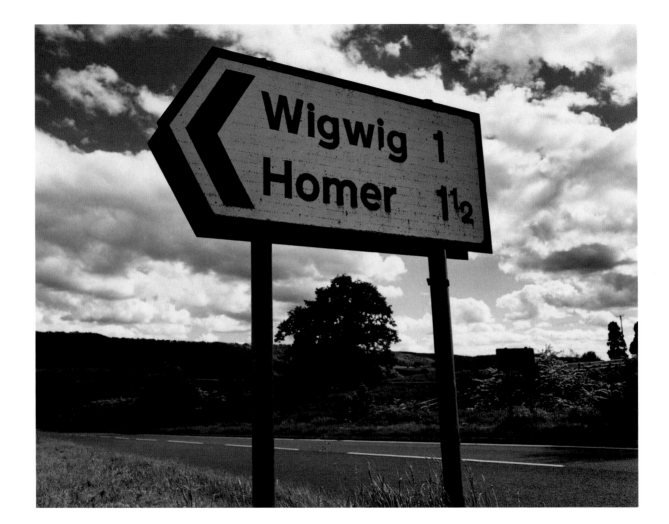

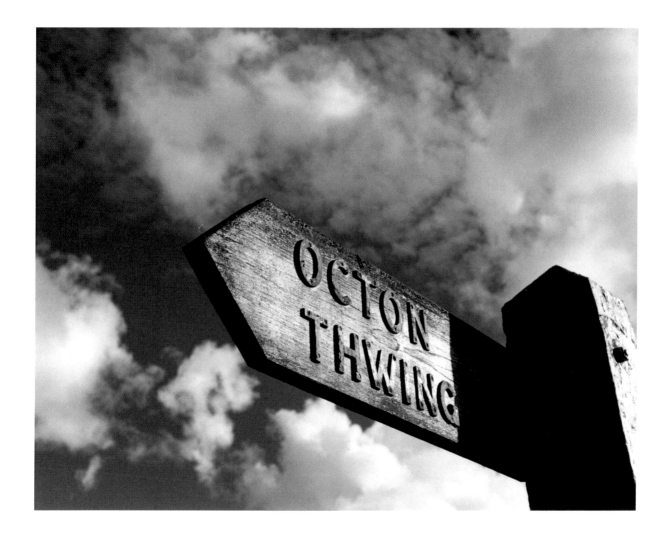

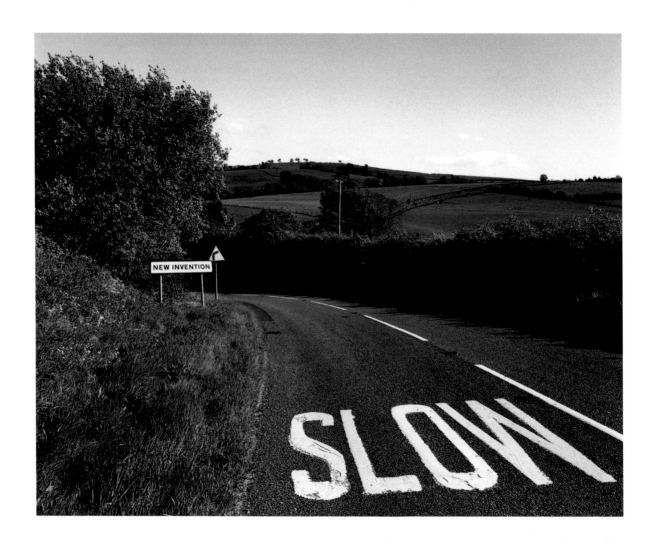

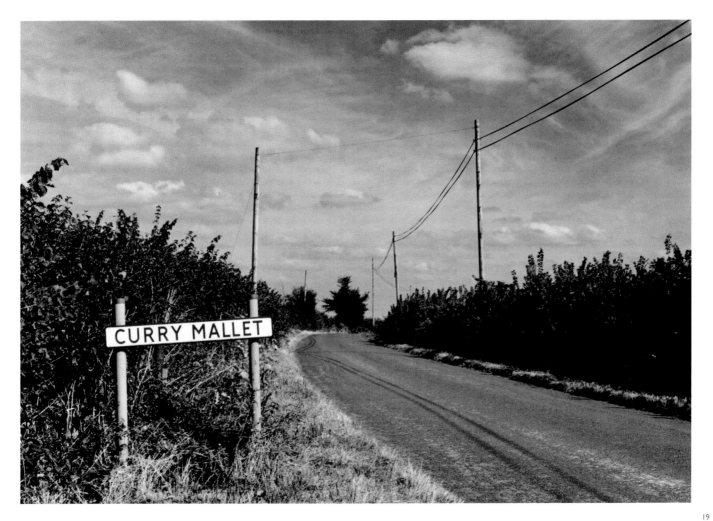

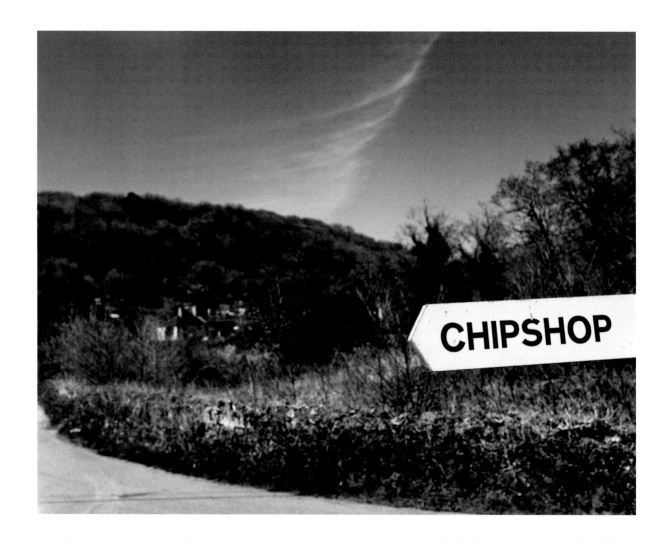

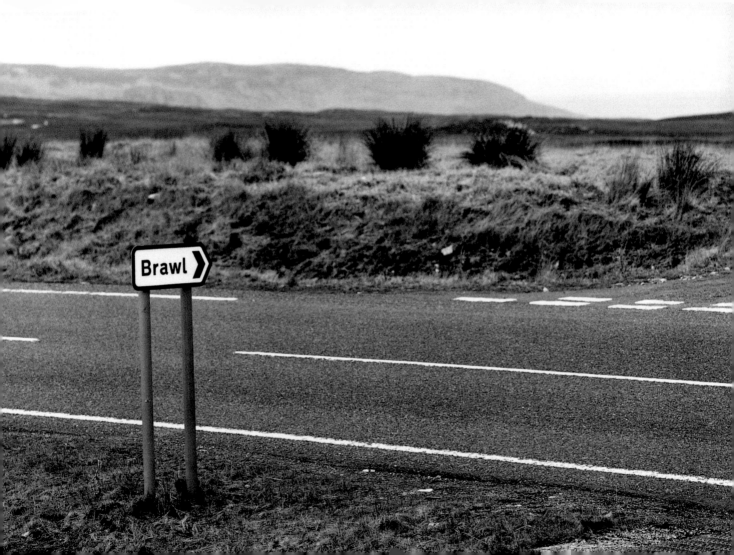

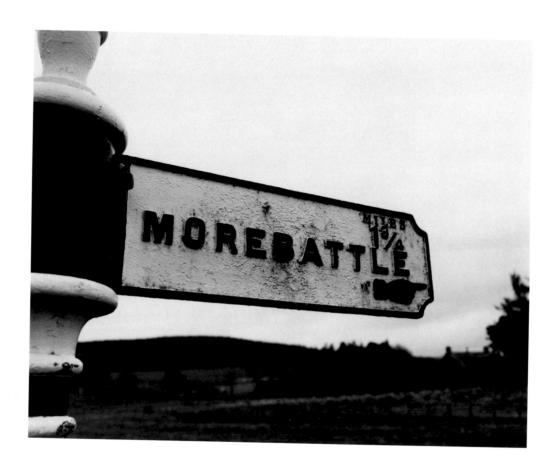

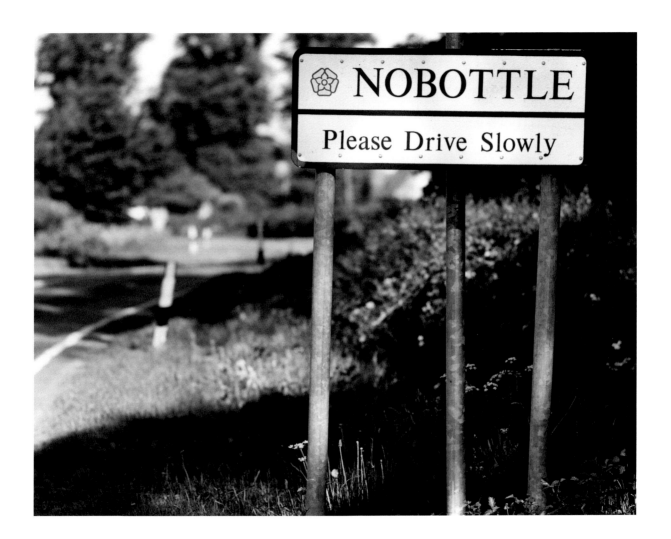

NOBOTTLE

Please Drive Slowly

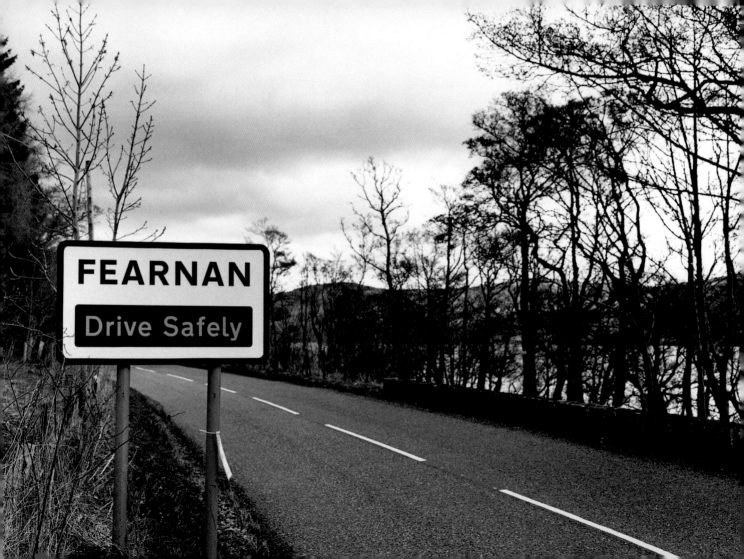

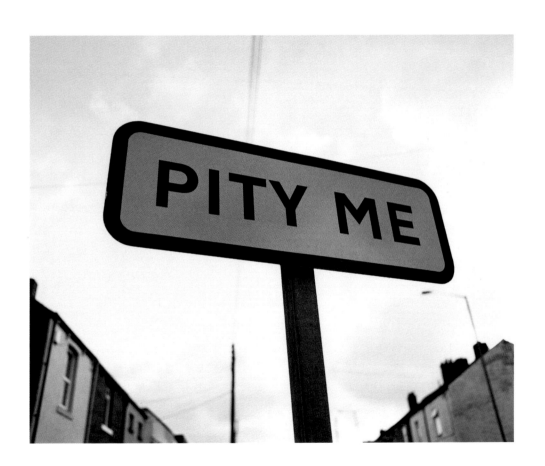

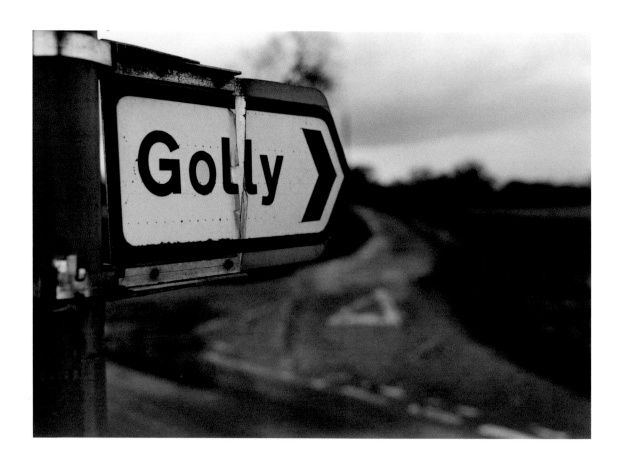

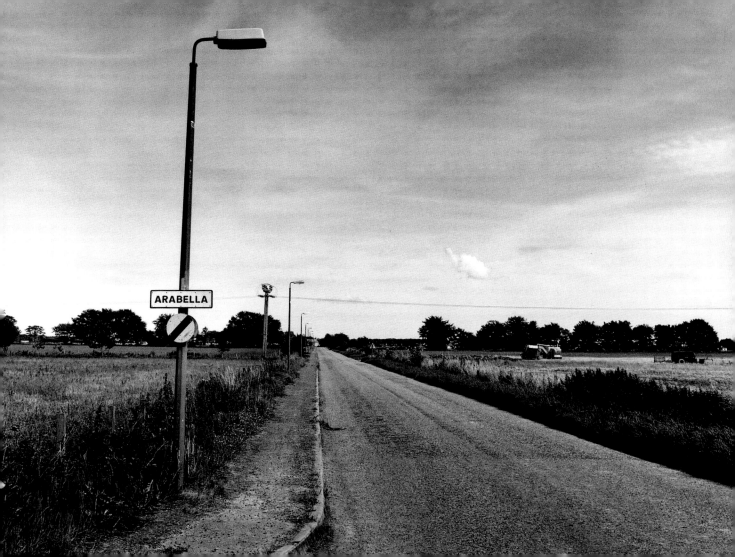

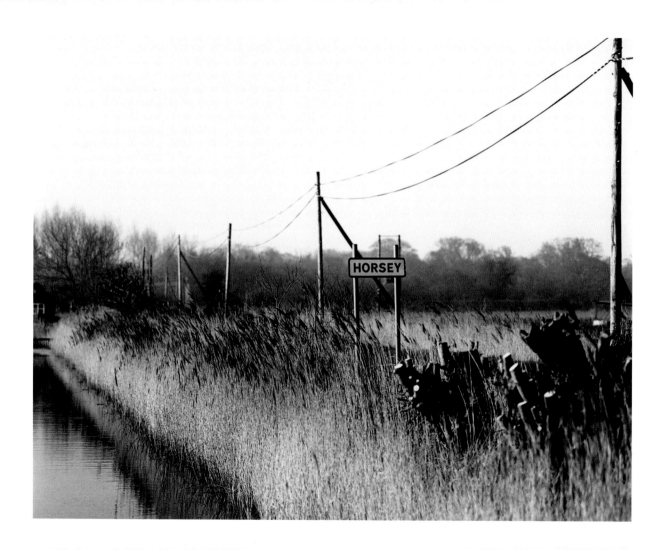

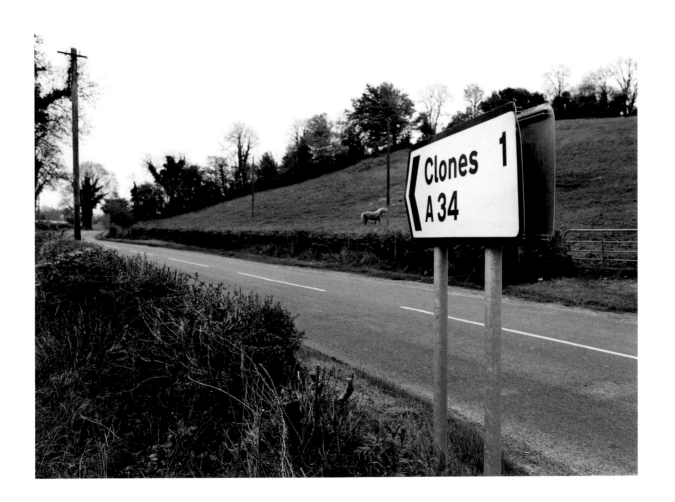

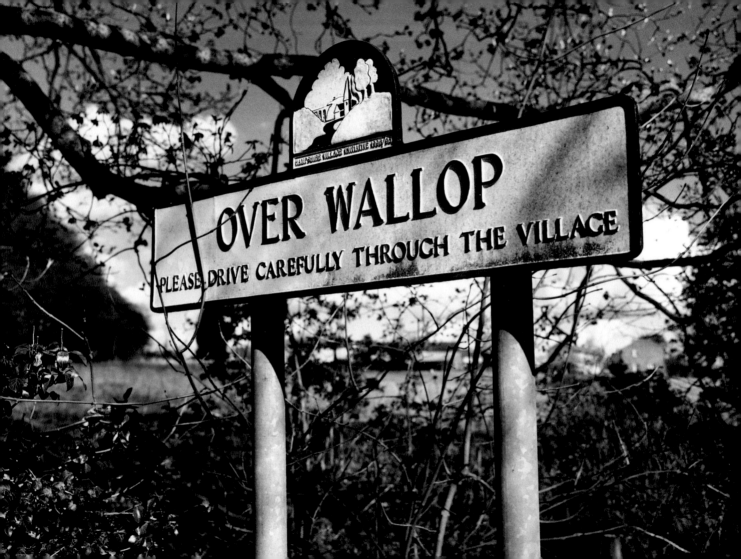

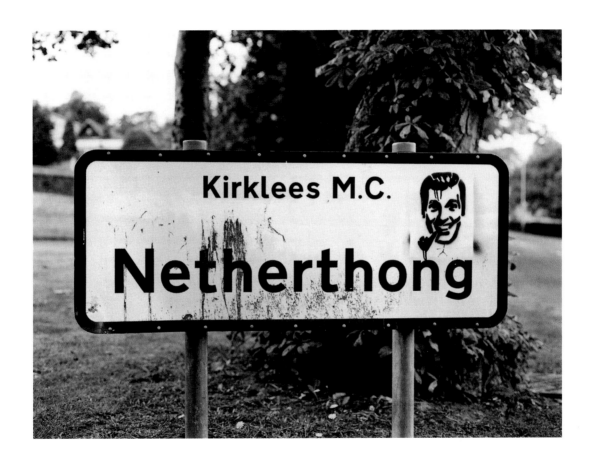

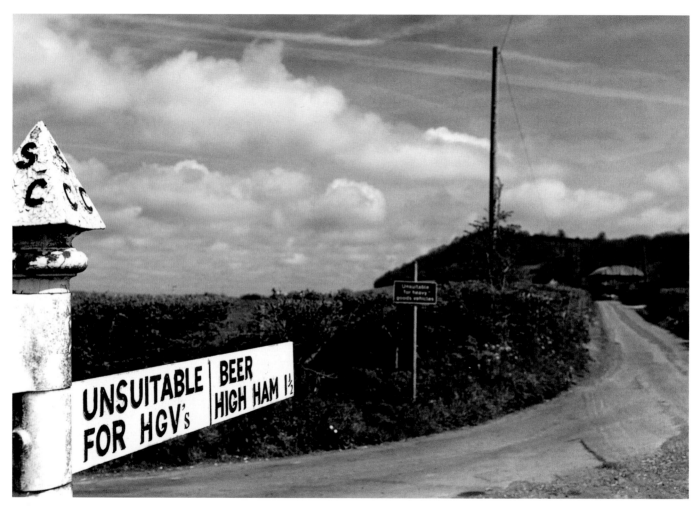

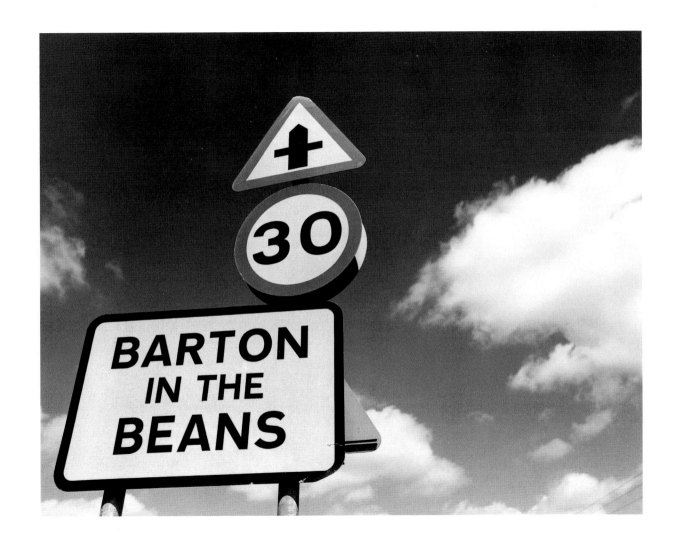

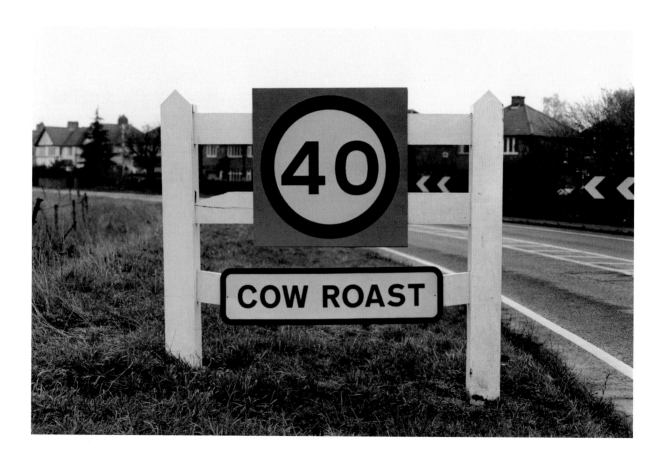

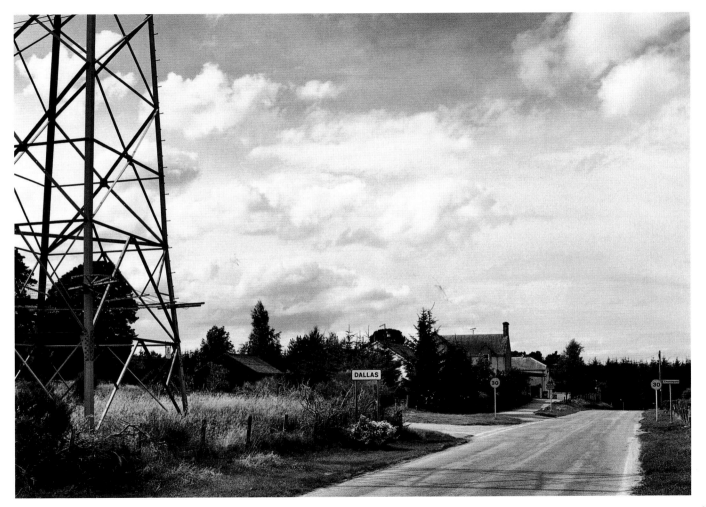

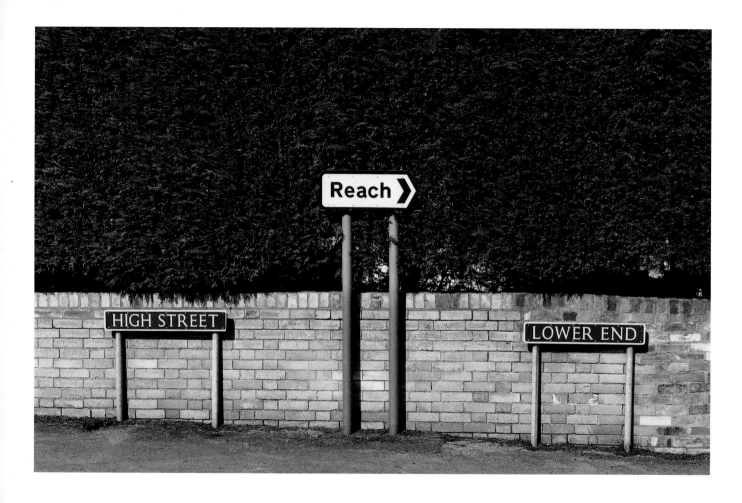

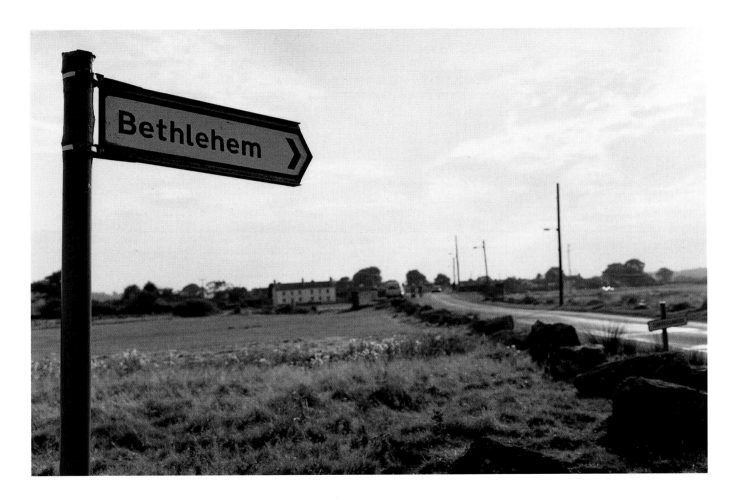

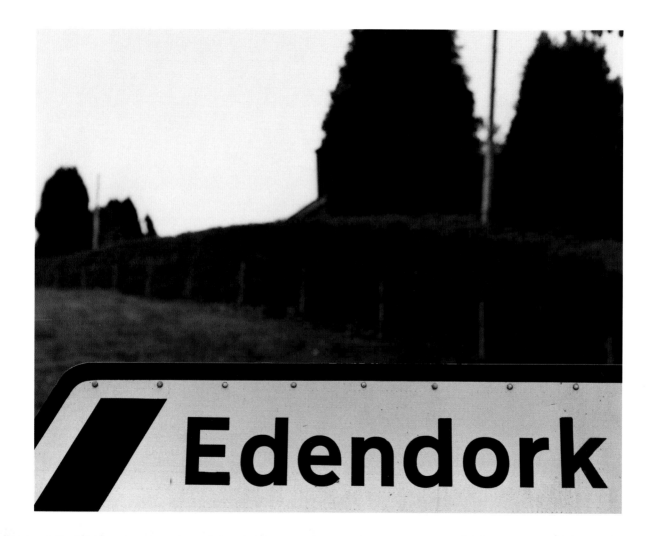

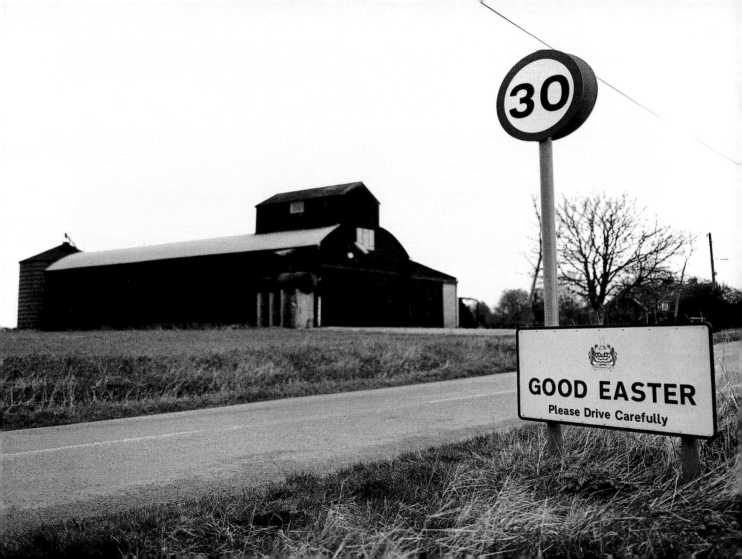

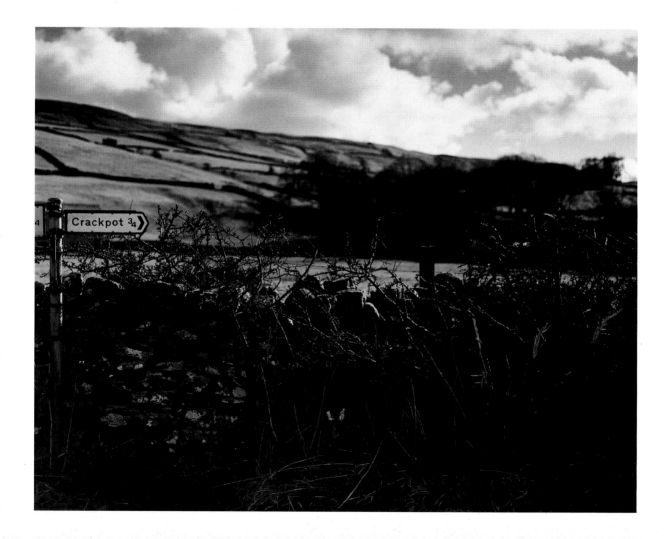

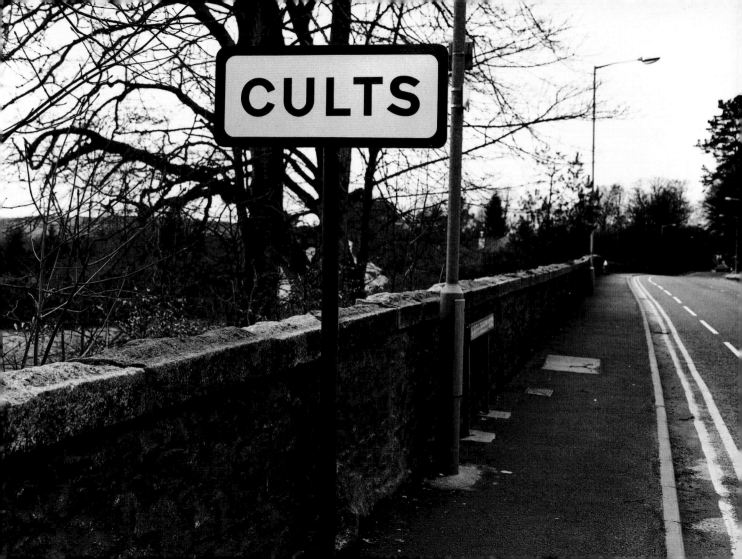

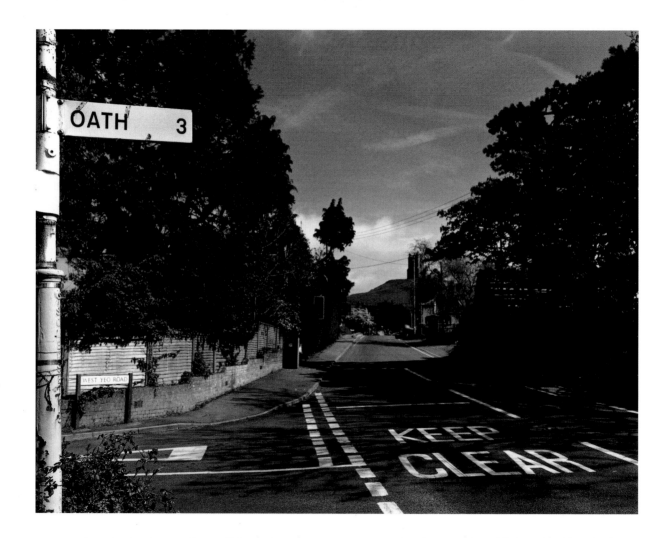

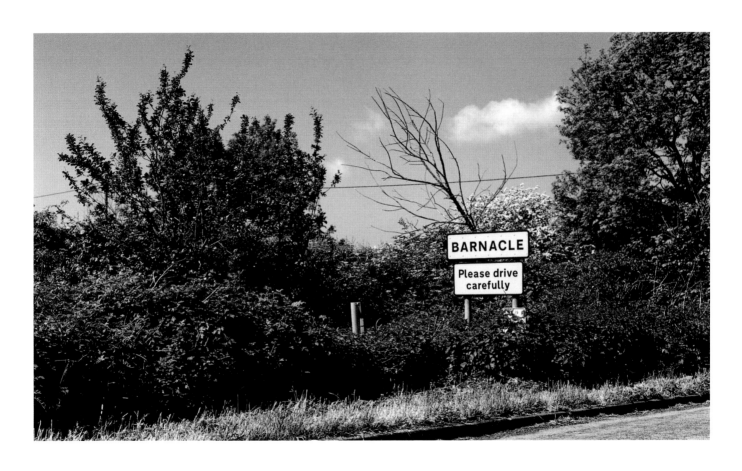

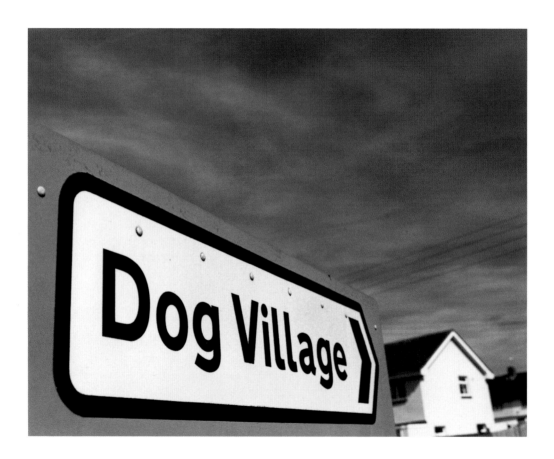

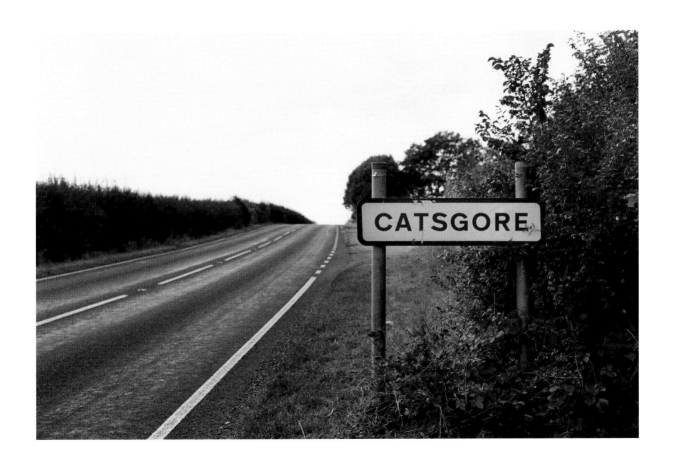

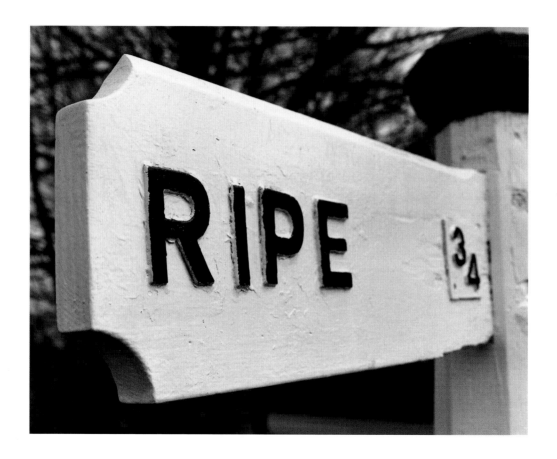

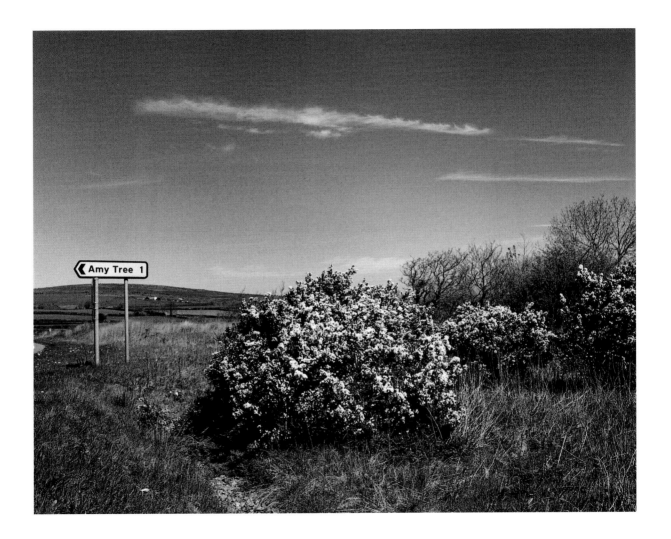

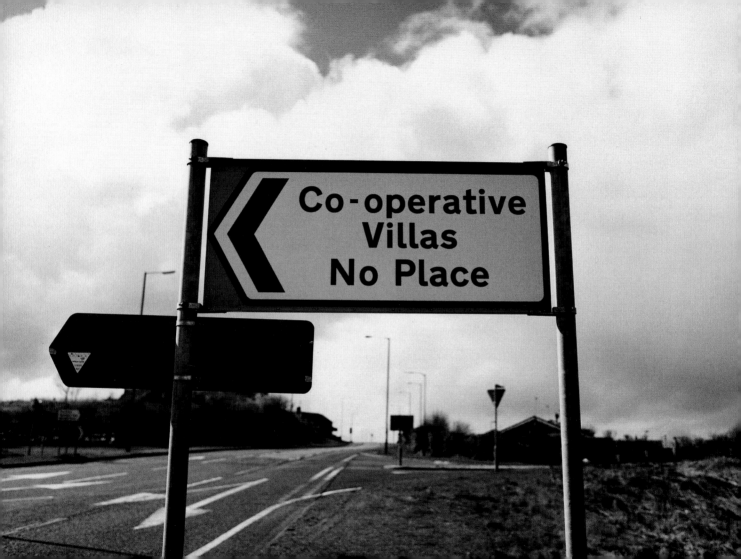

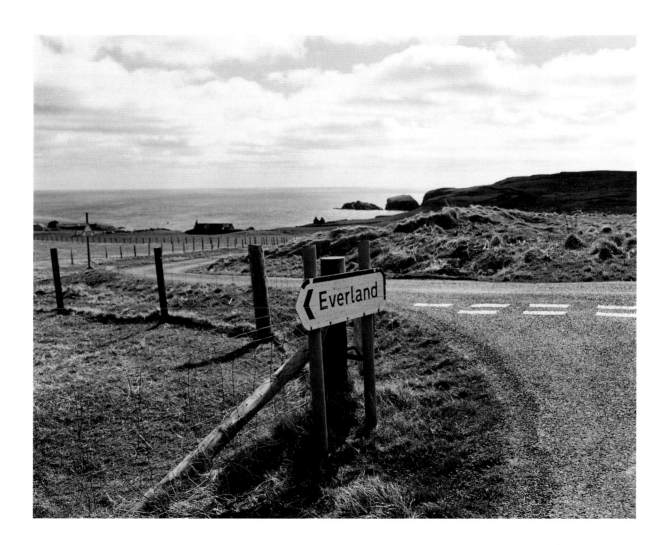

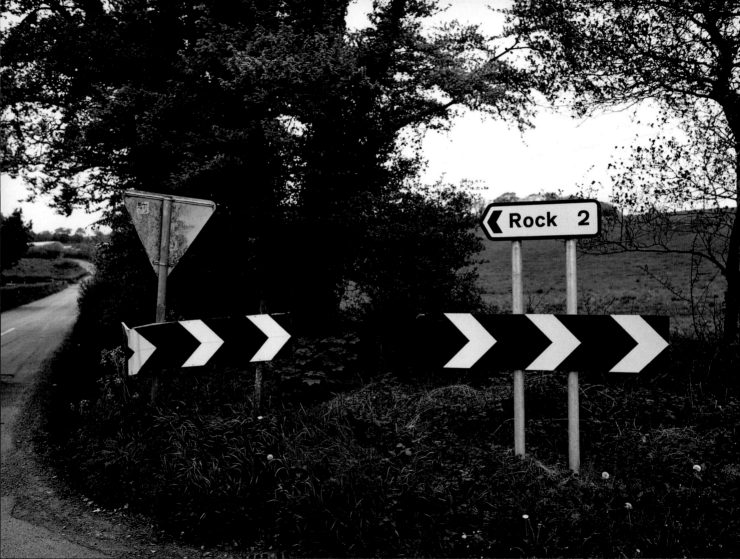

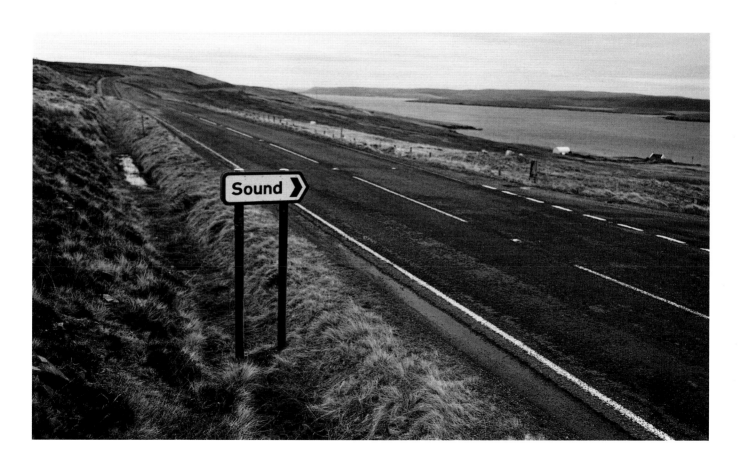

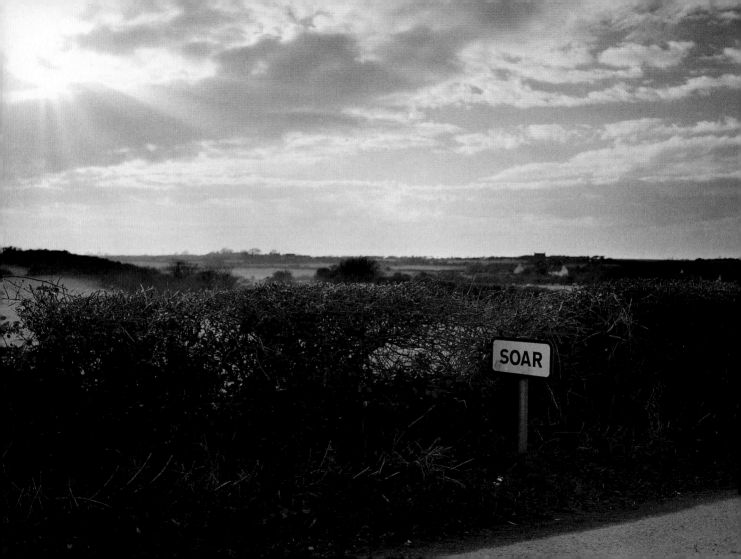

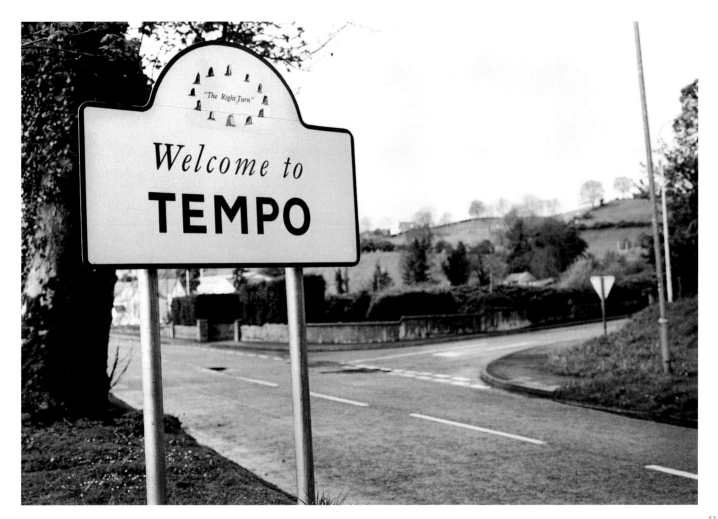

53

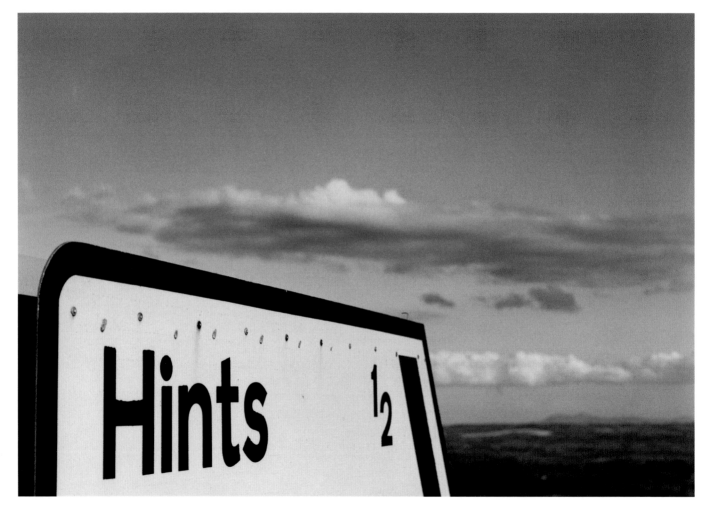

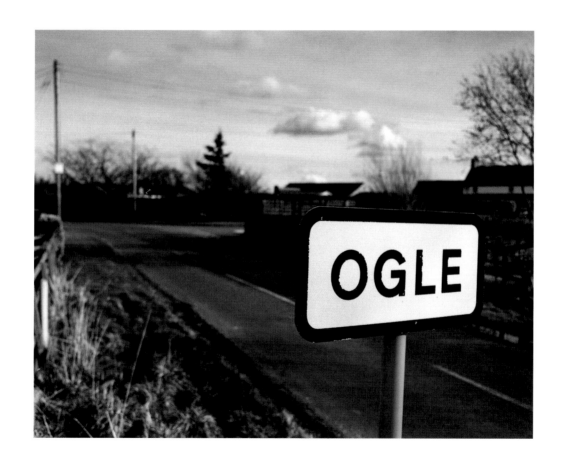

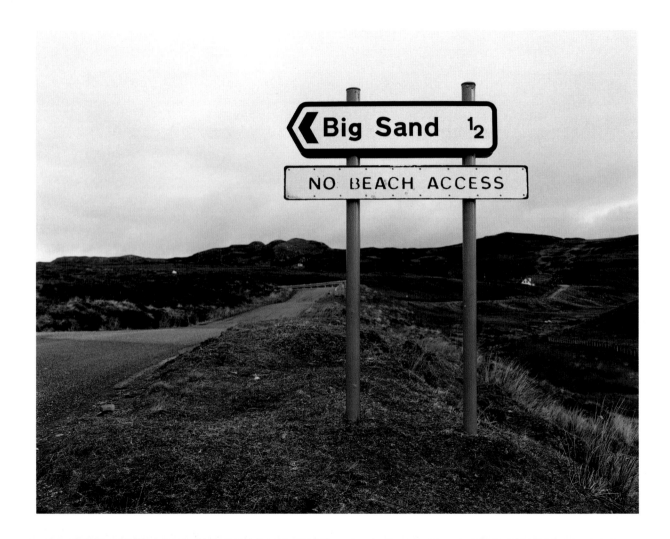

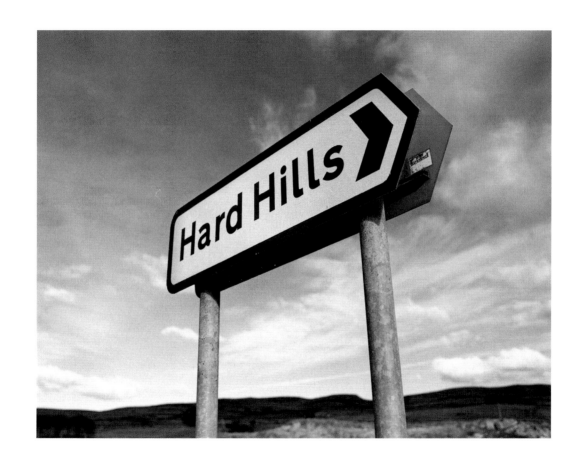

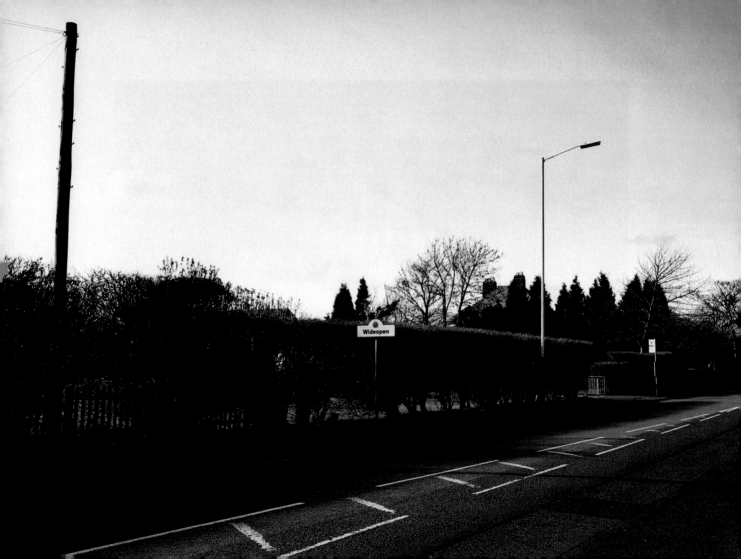

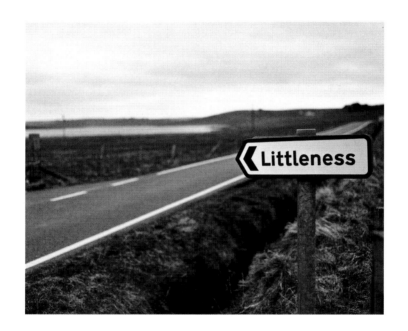

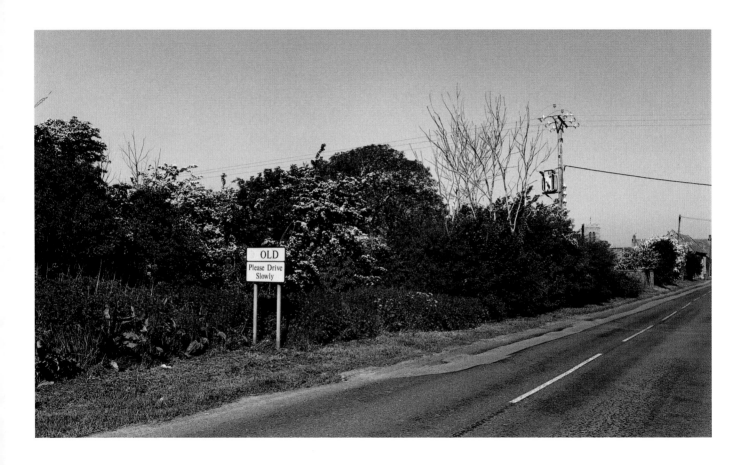

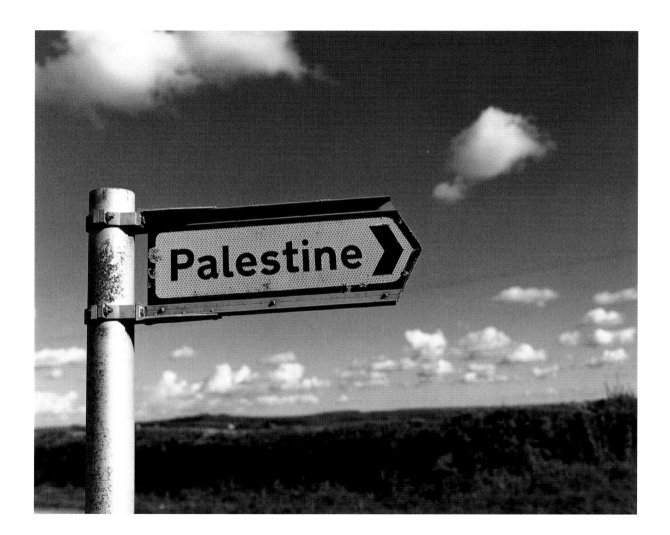

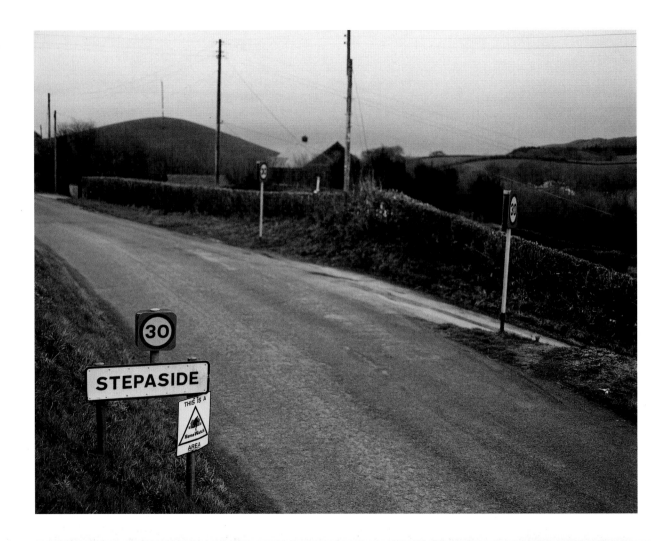

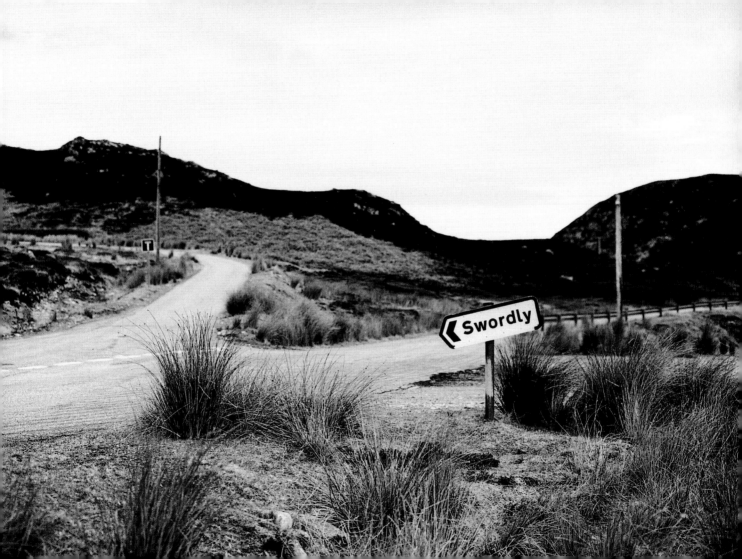

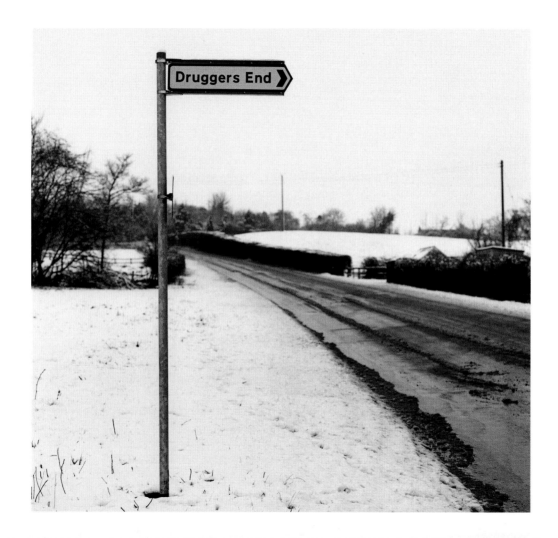

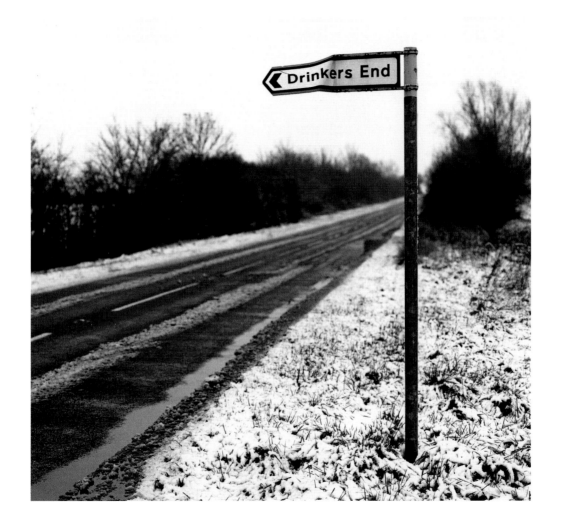

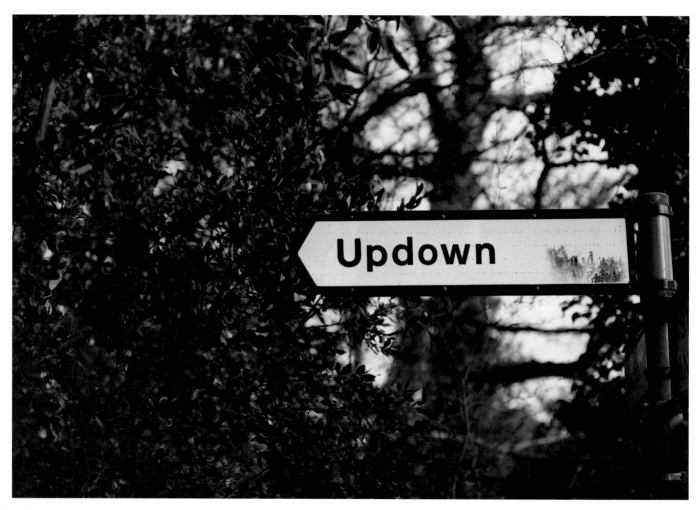

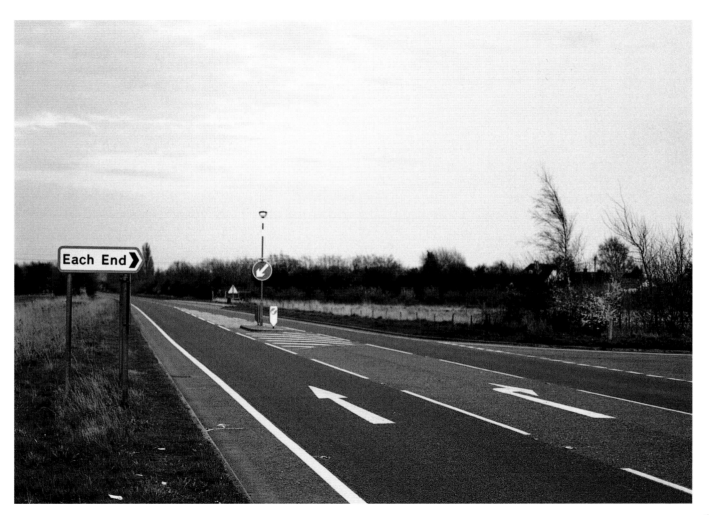

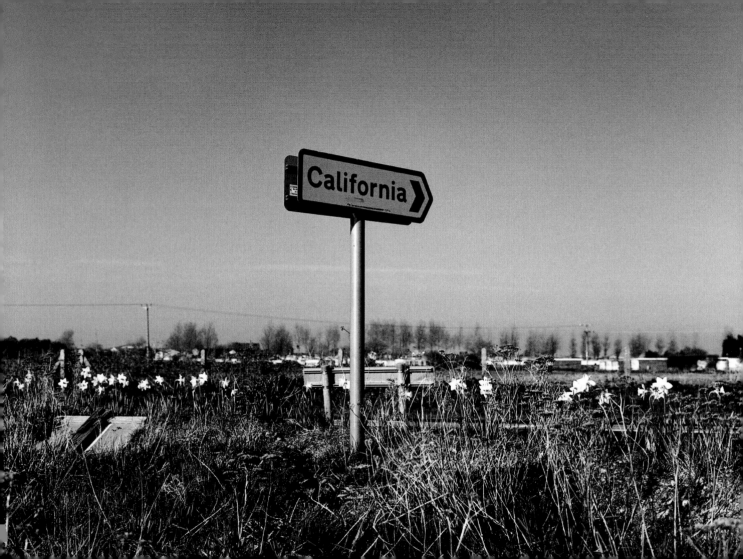

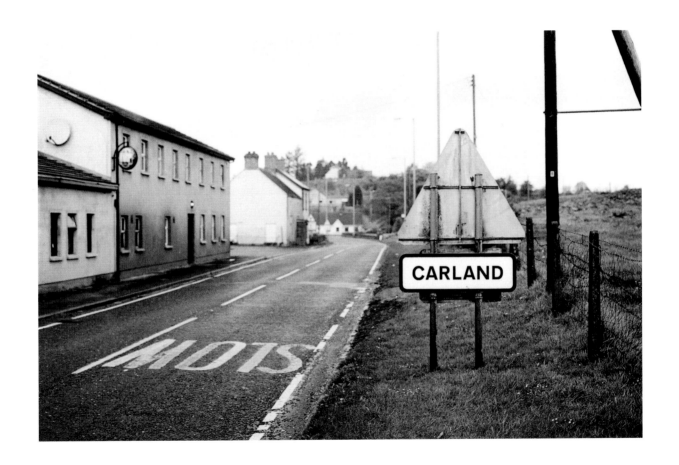

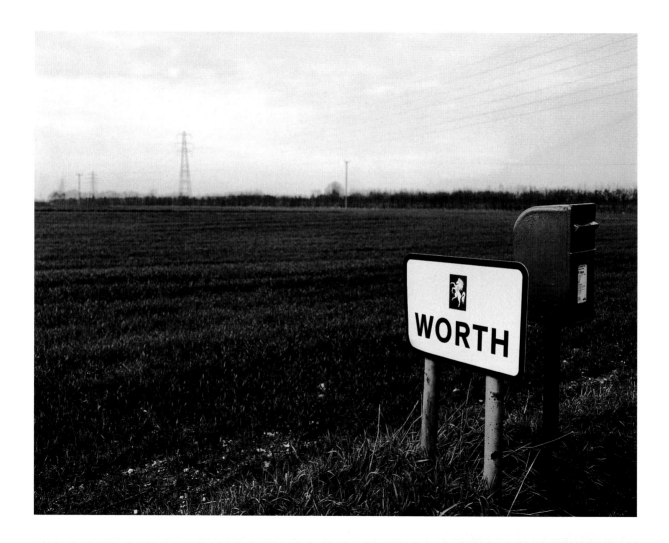

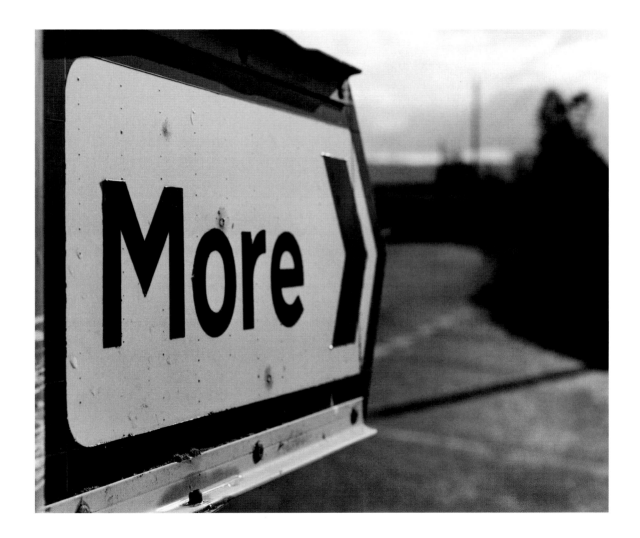

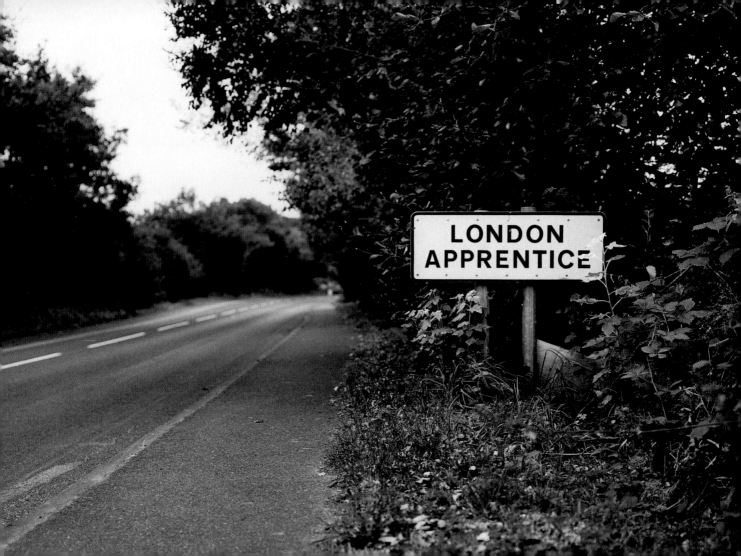

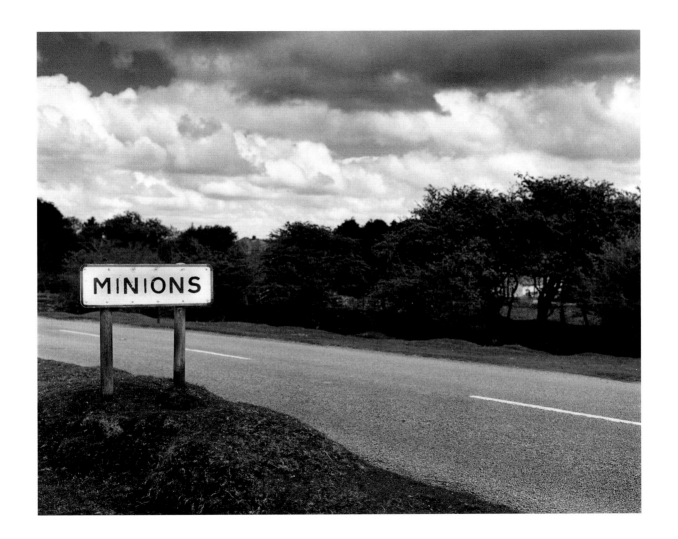

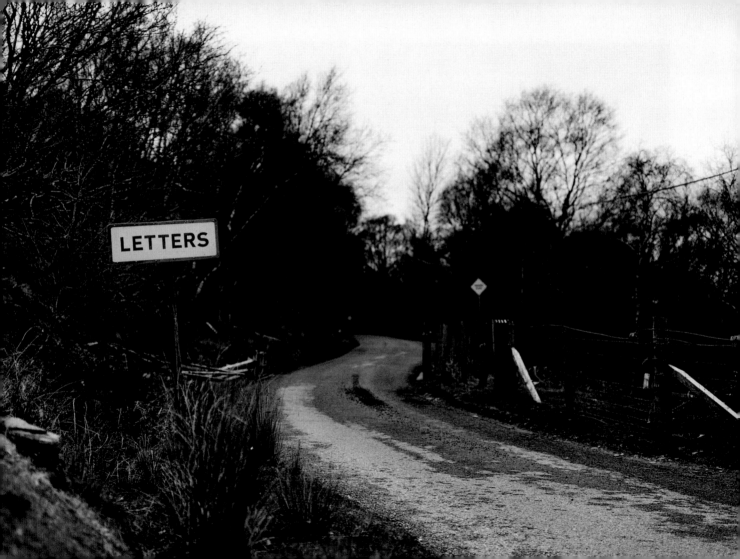

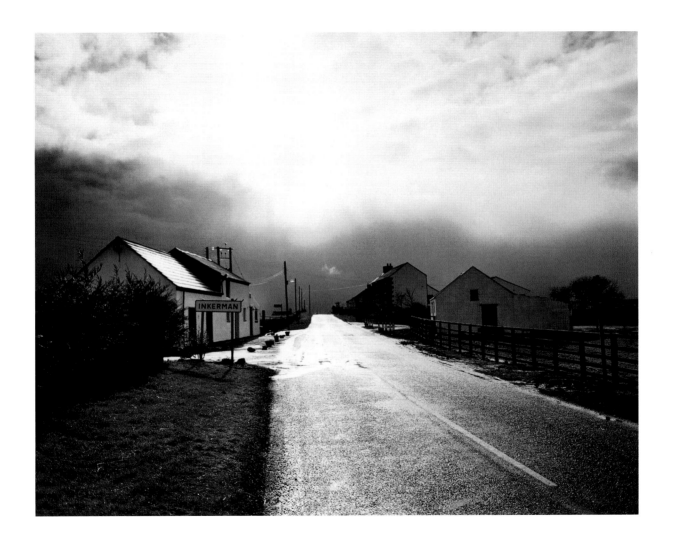

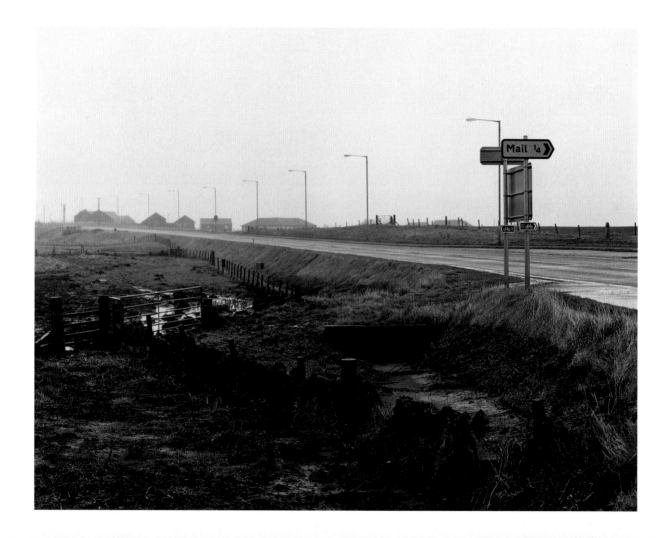

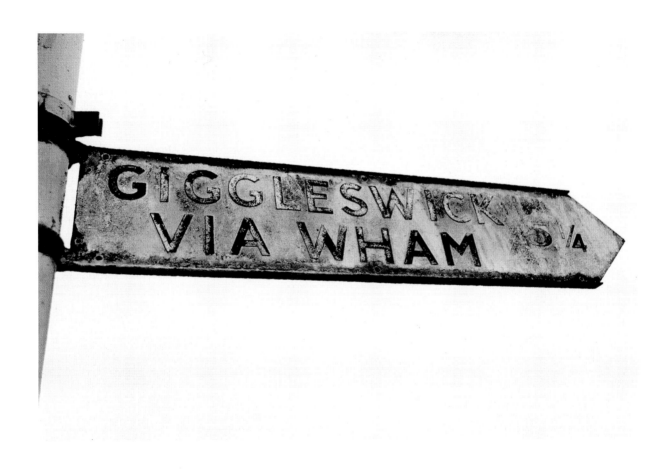

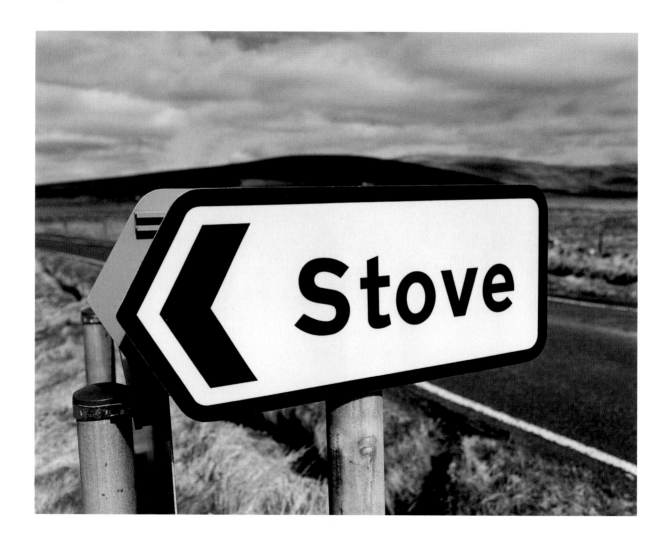

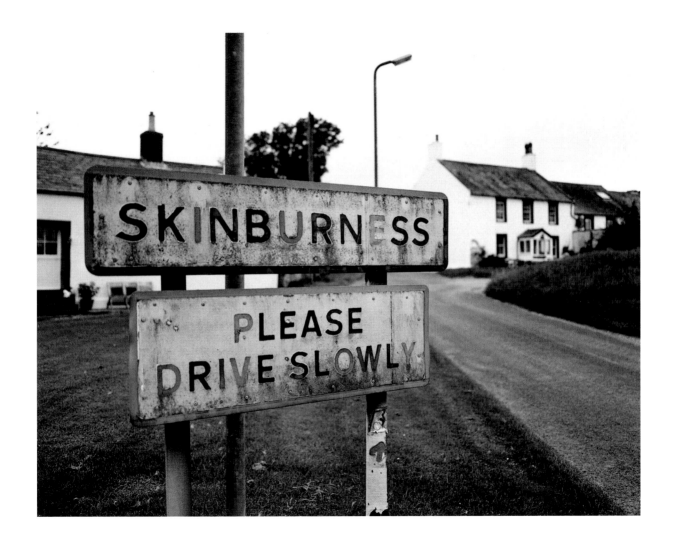

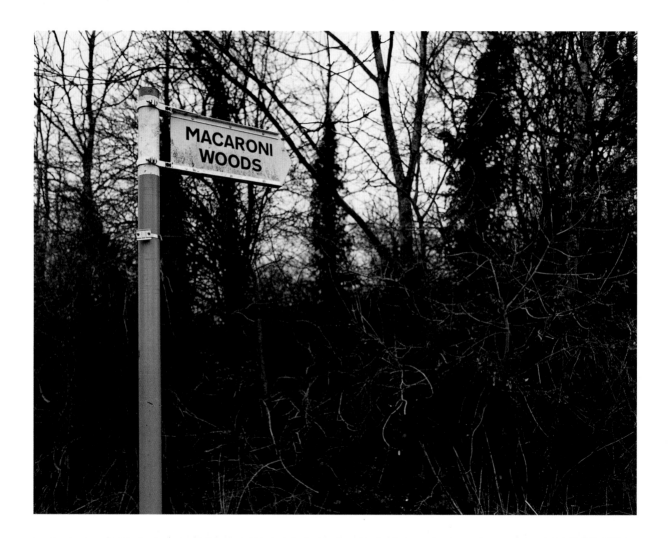

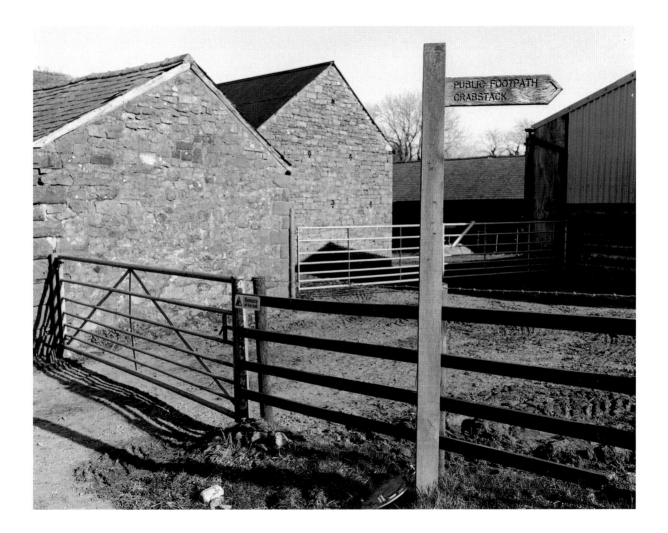

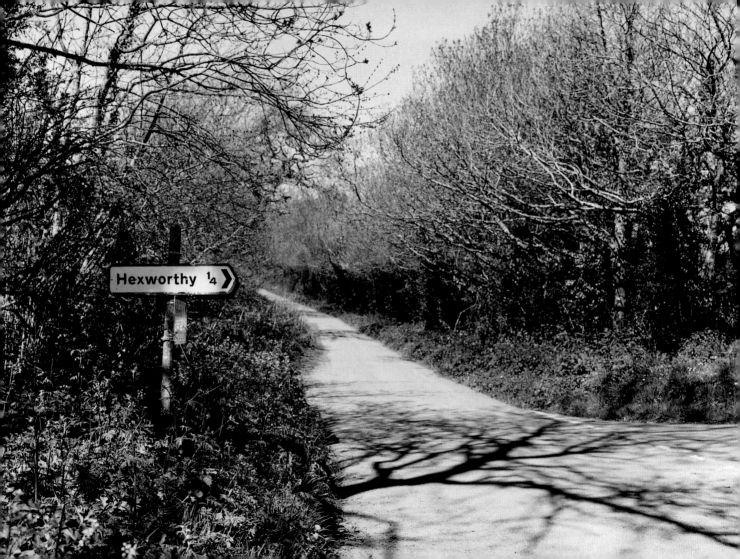

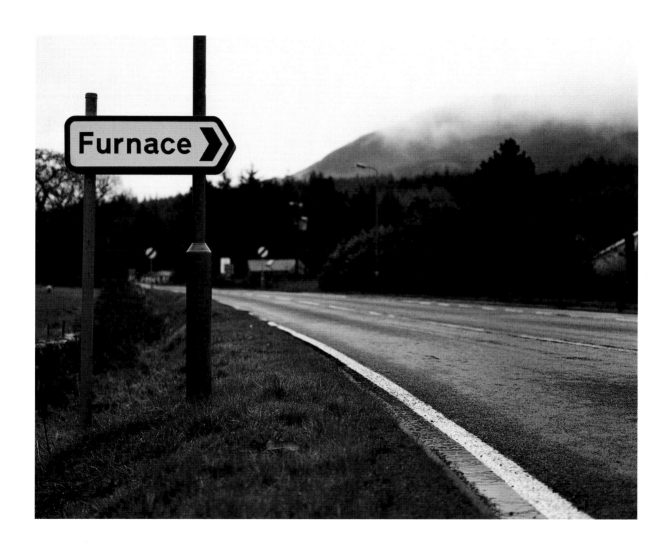

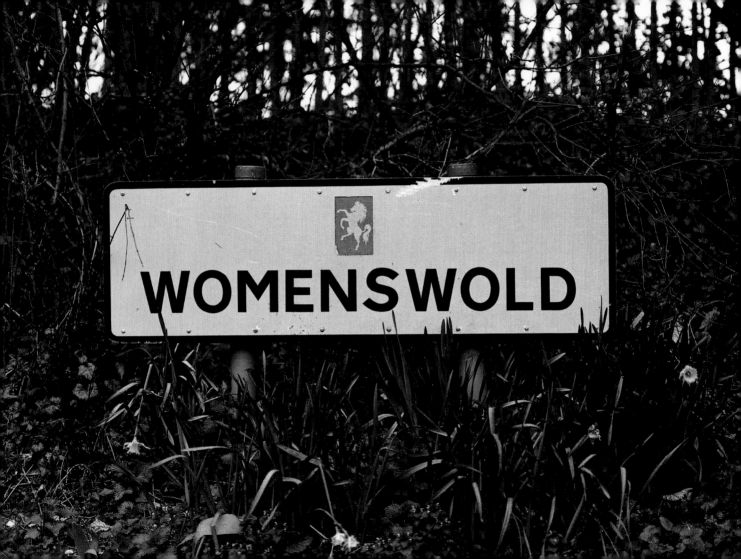

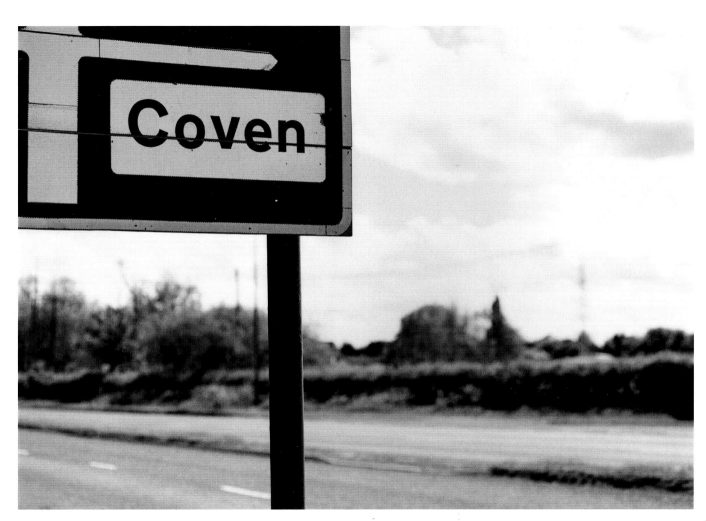

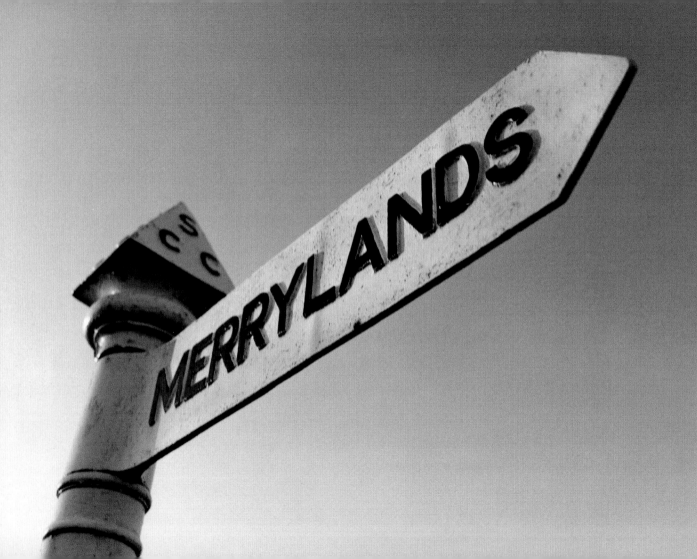

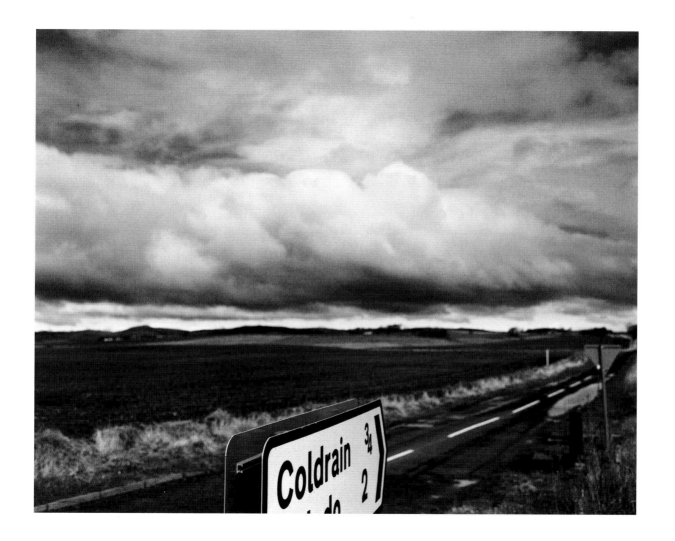

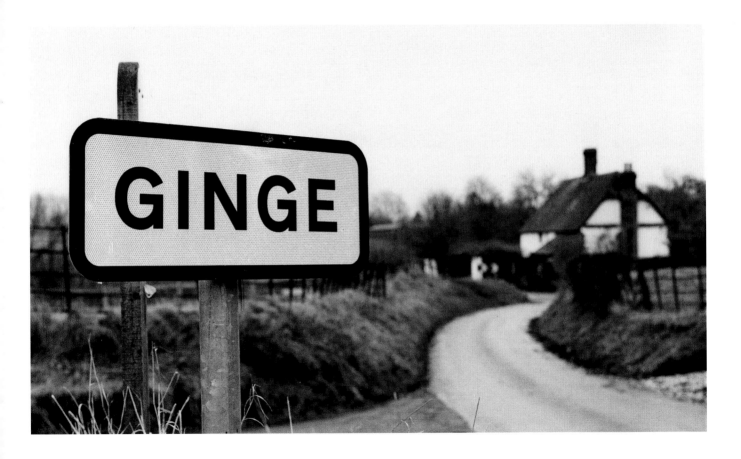

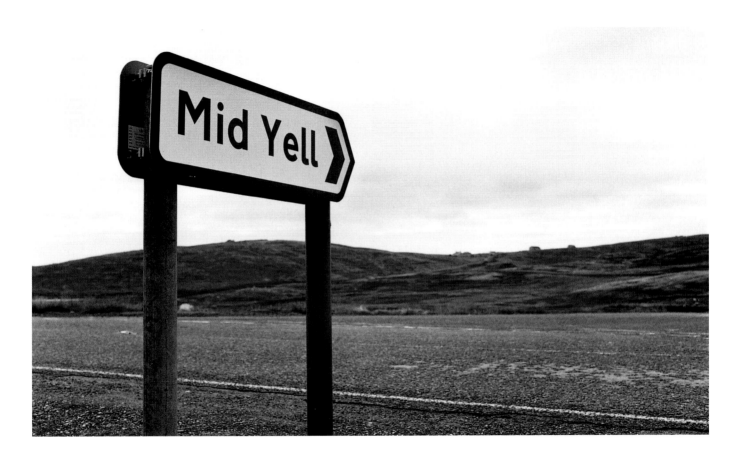

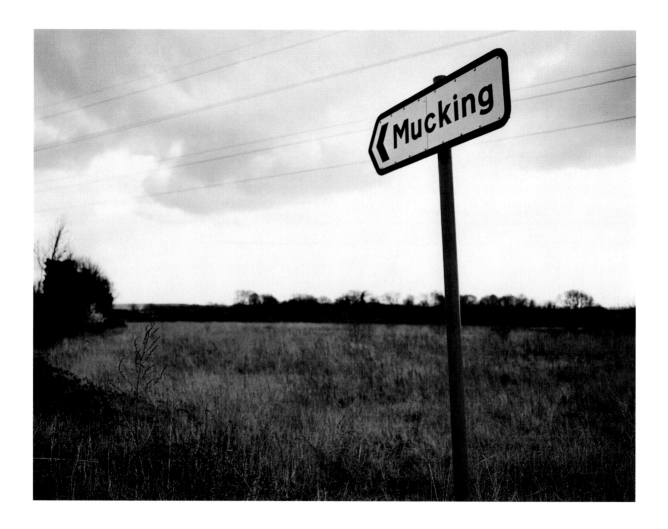

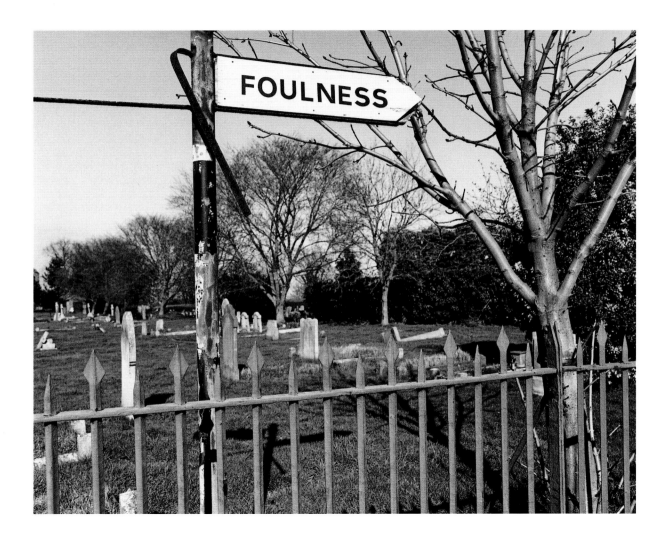

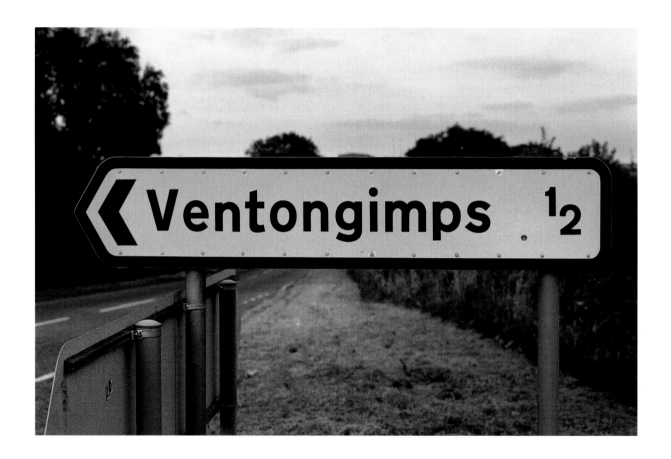

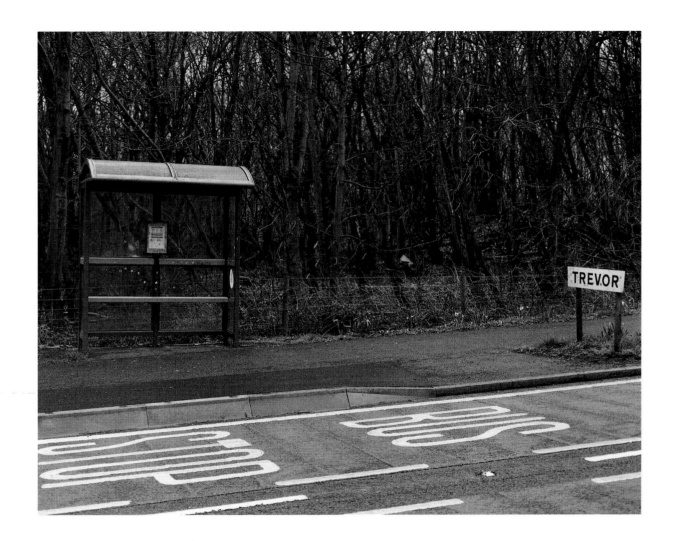

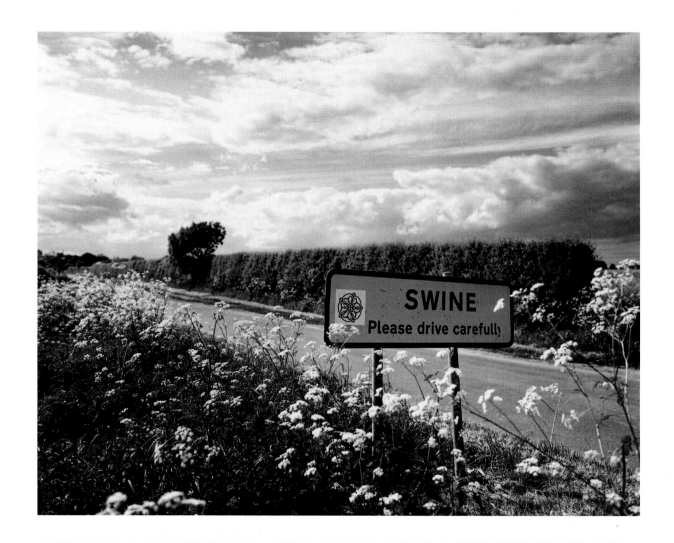

LOWER SLAUGHTER
Please Drive Carefully
Through the Village

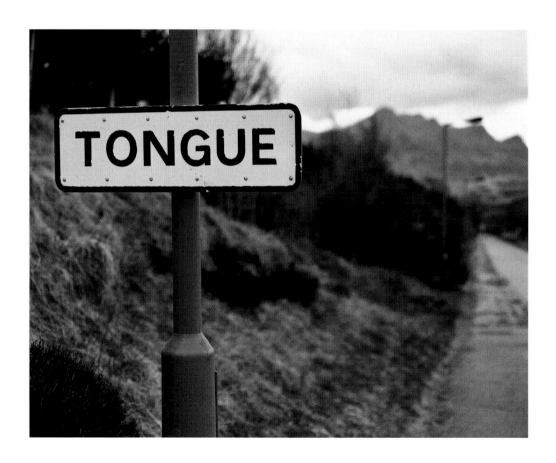

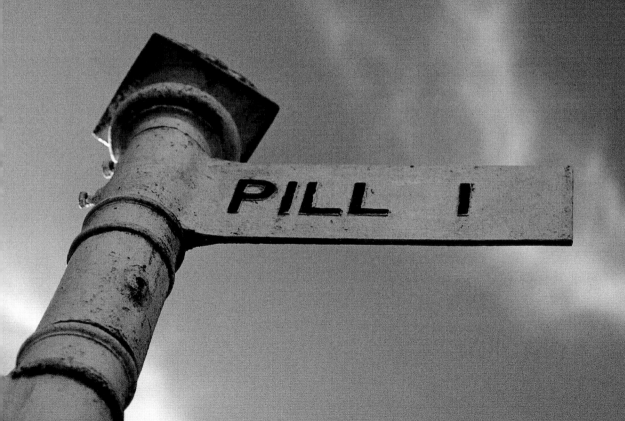

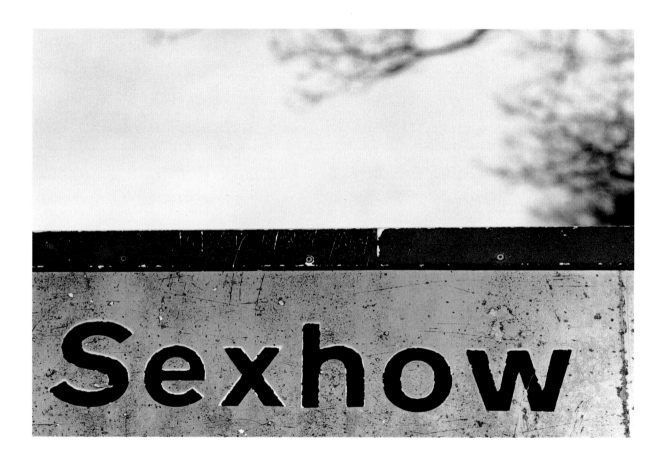

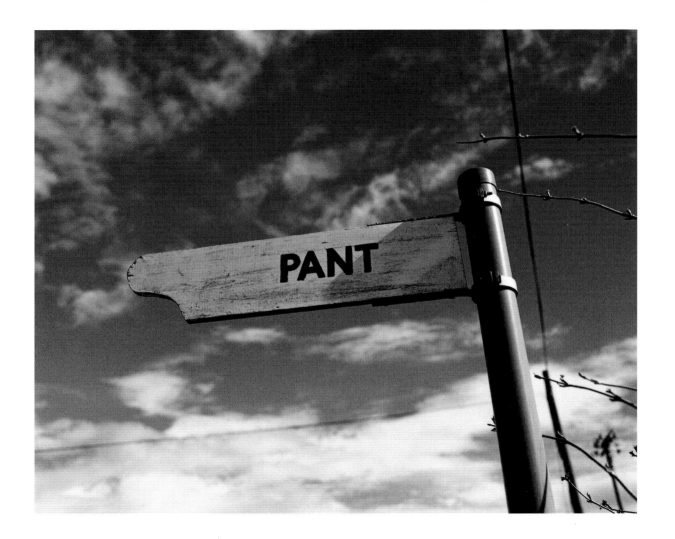

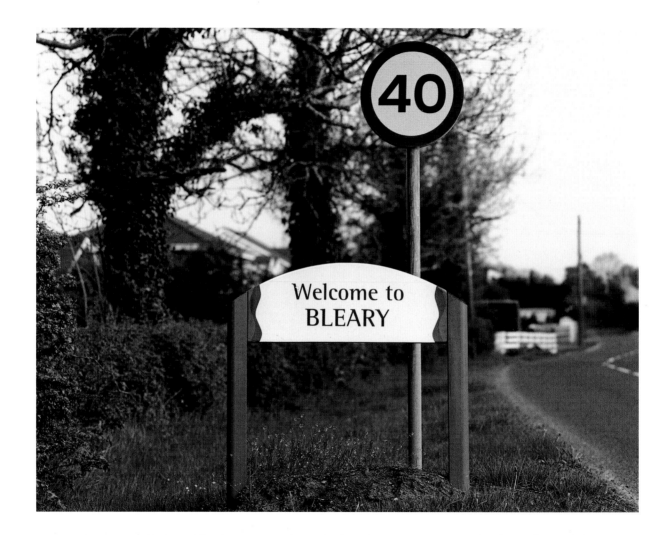

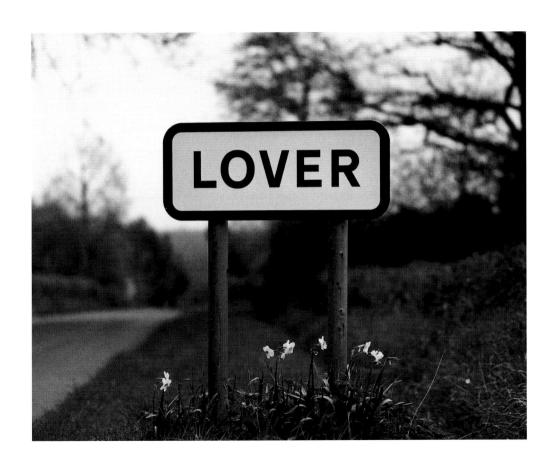

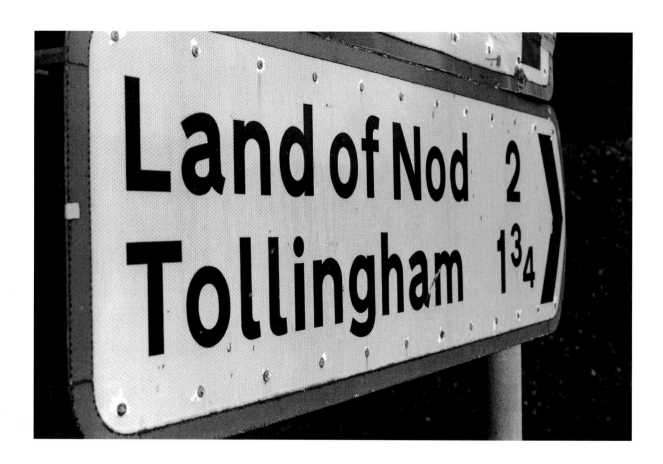

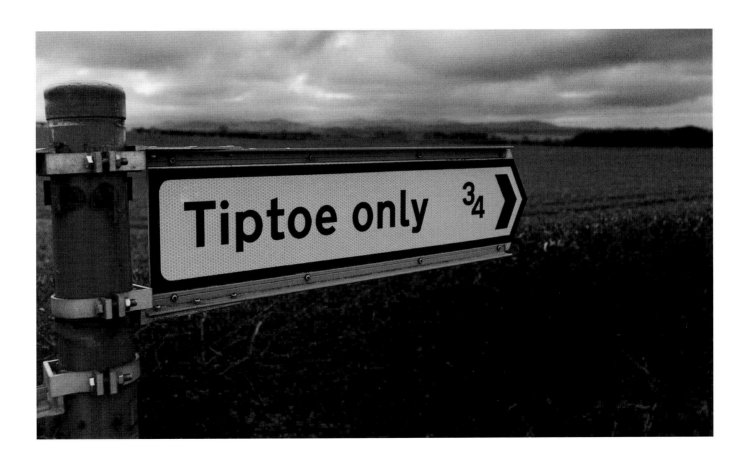

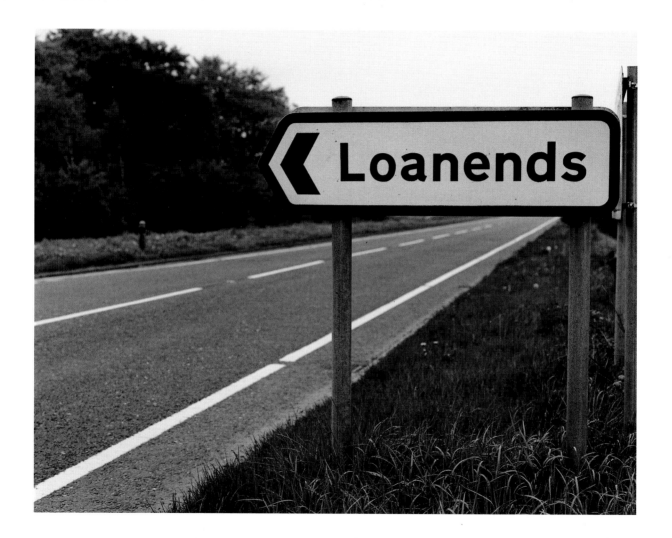

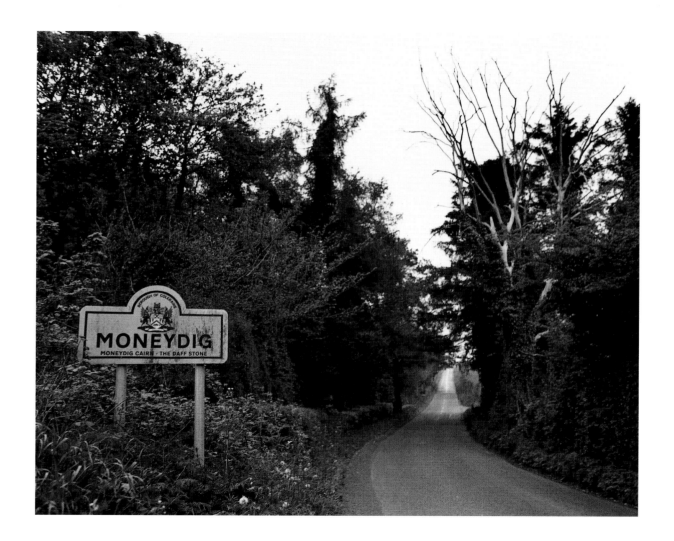

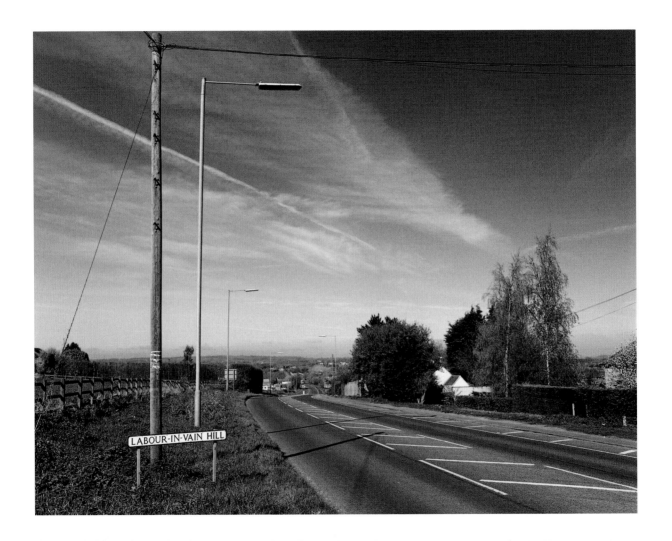

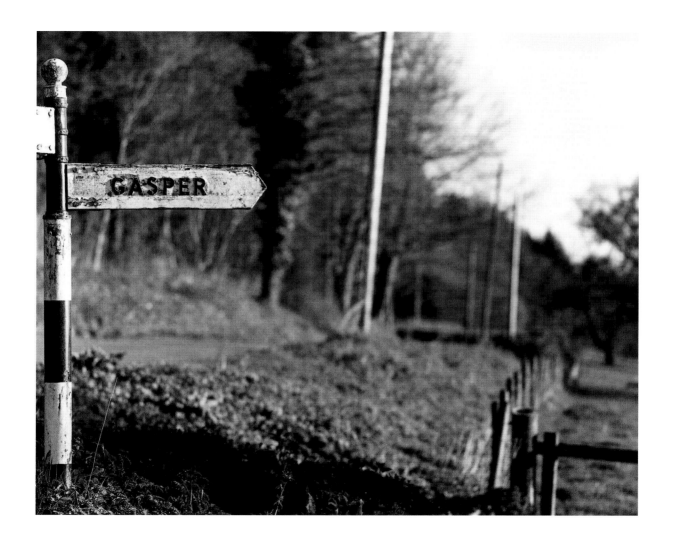

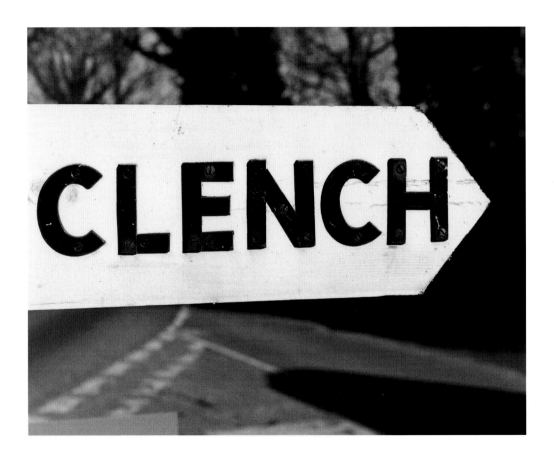

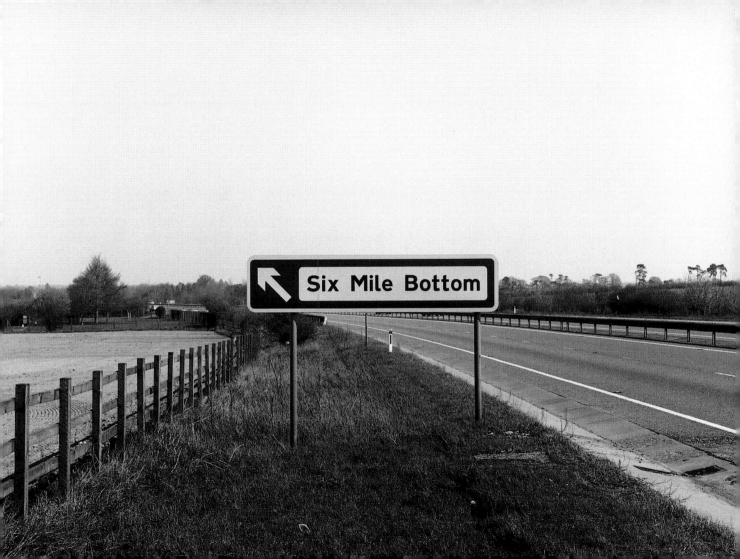

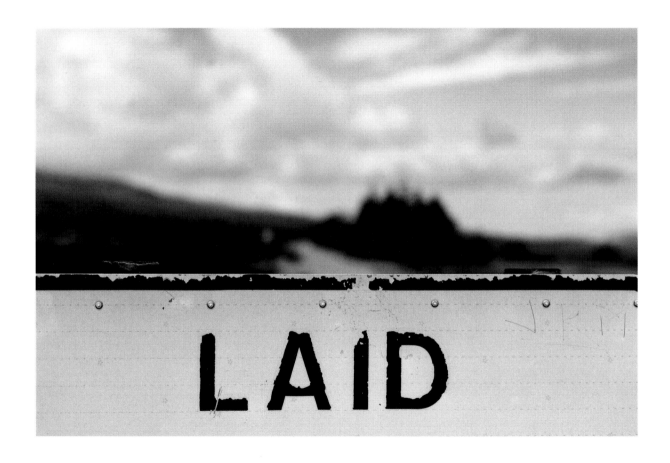

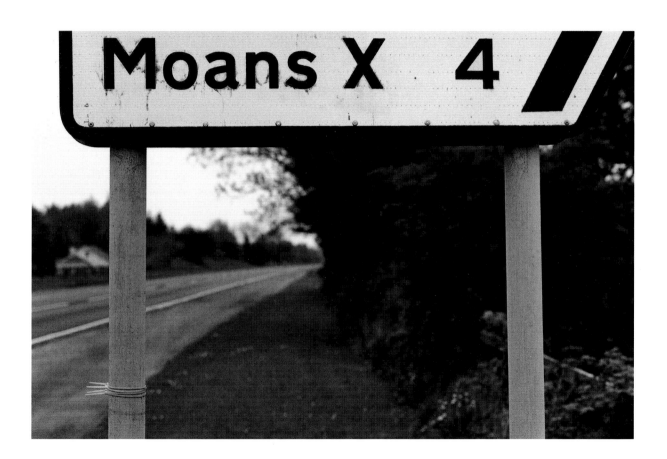

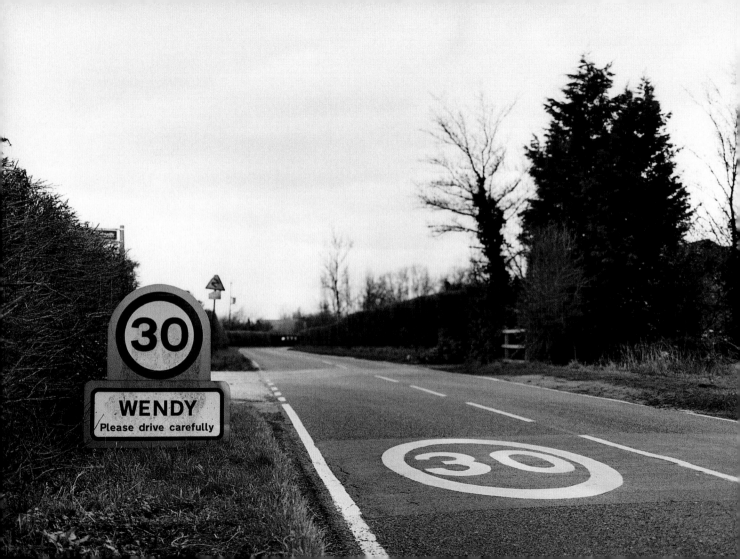

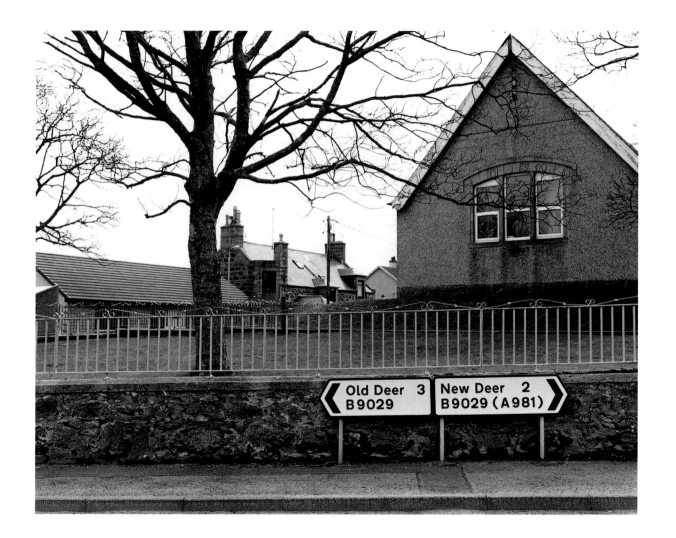

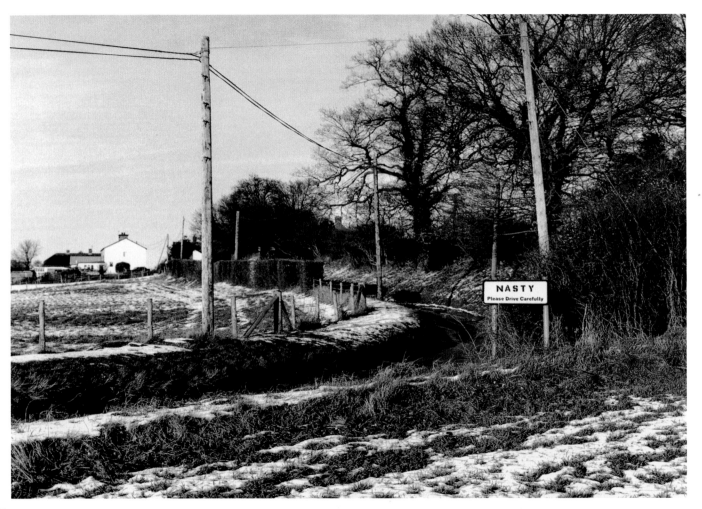

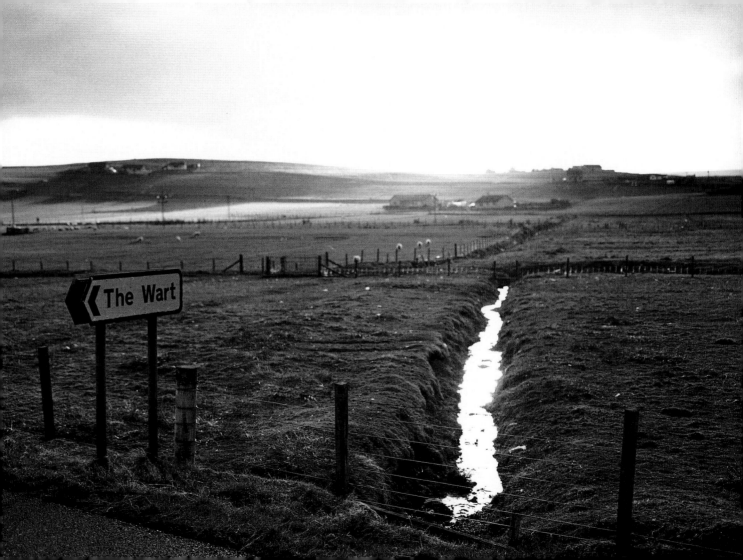

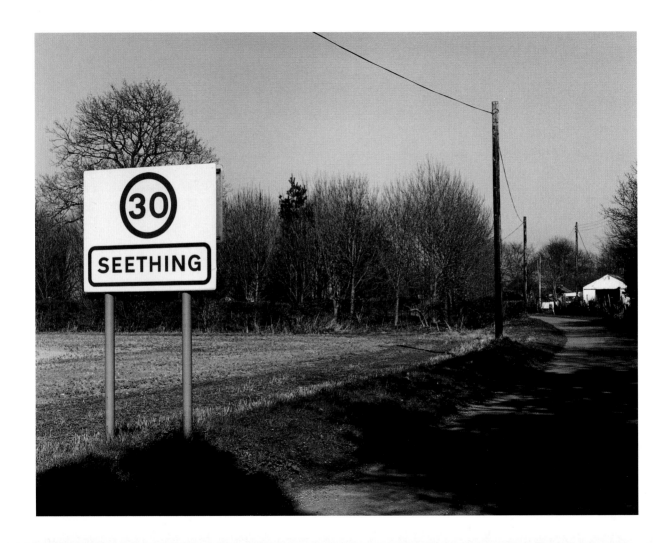

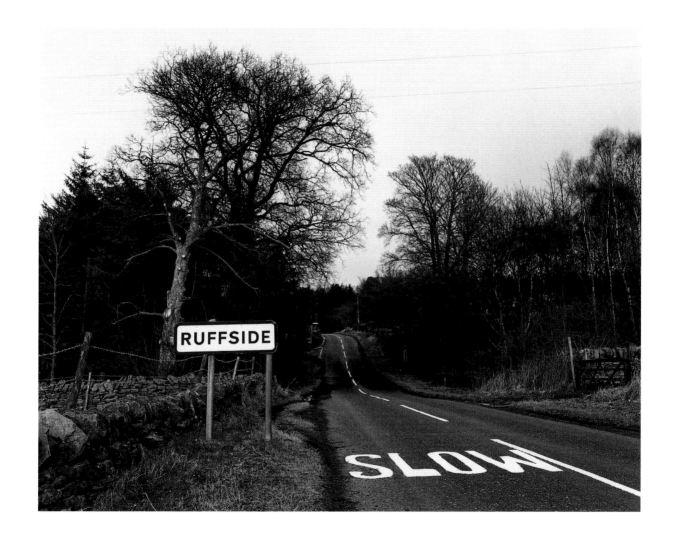

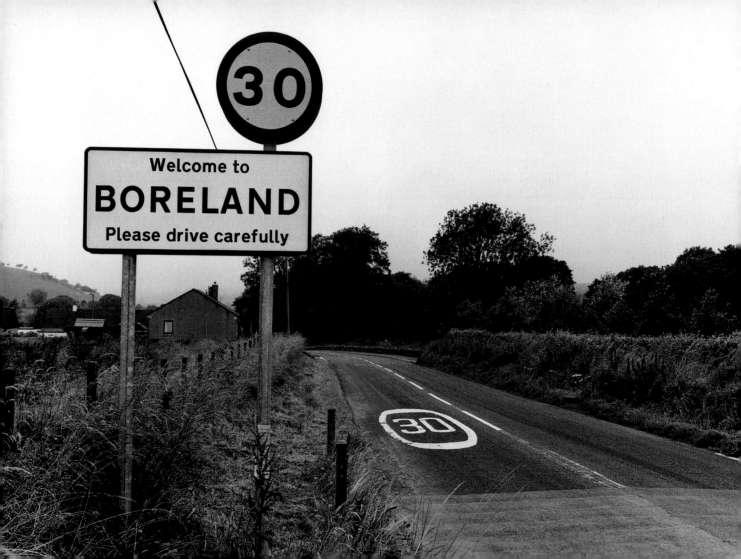

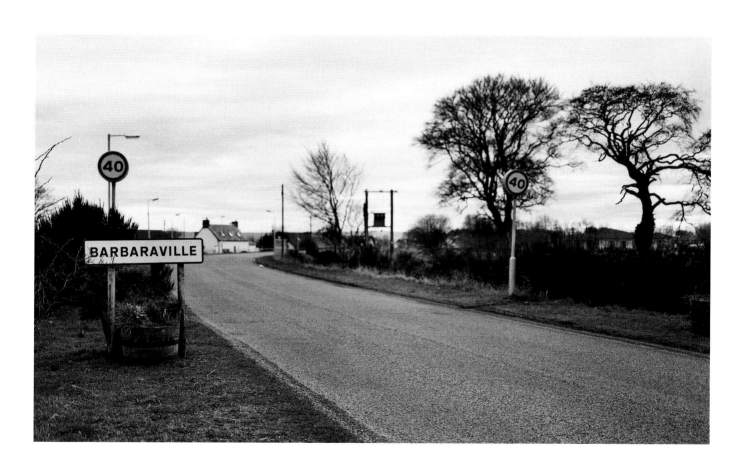

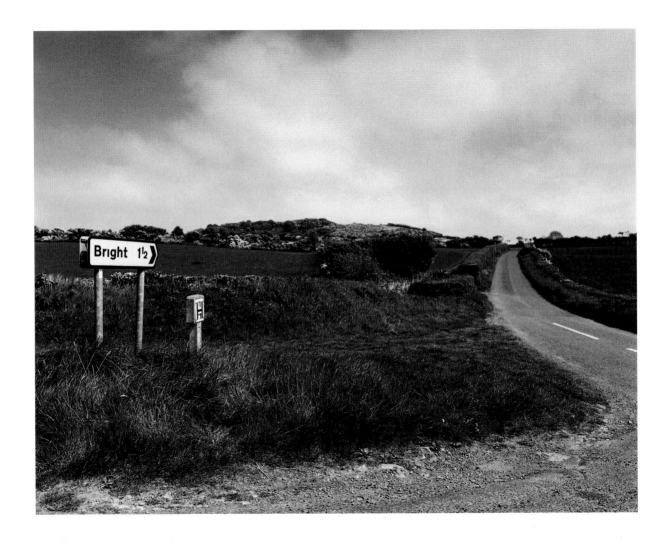

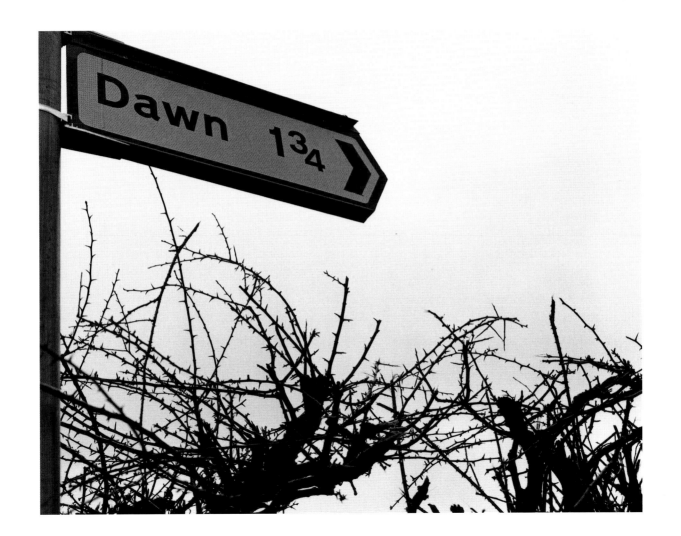

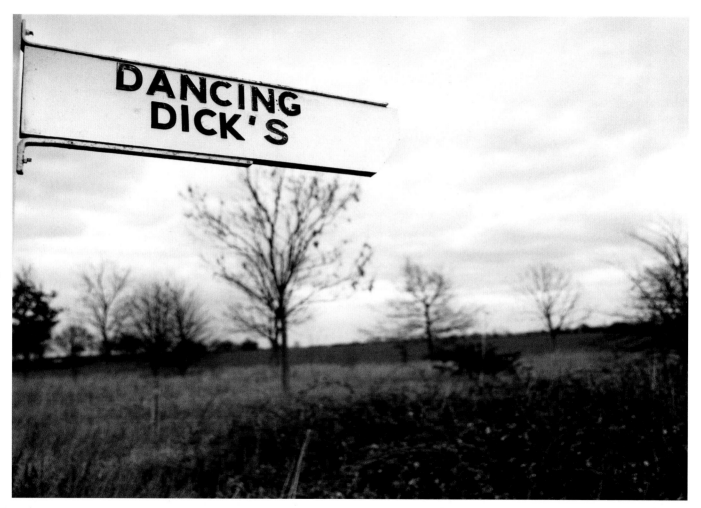

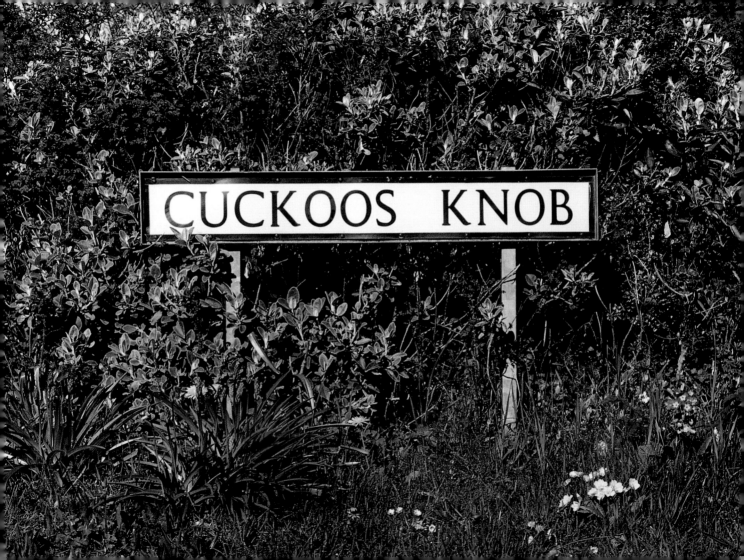

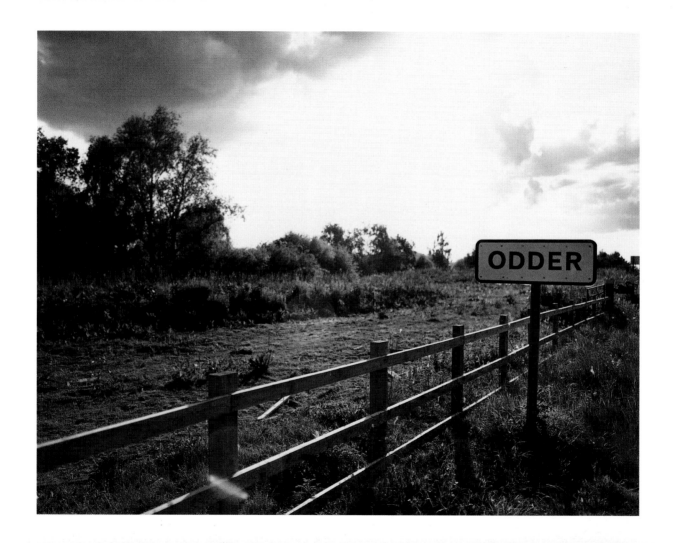

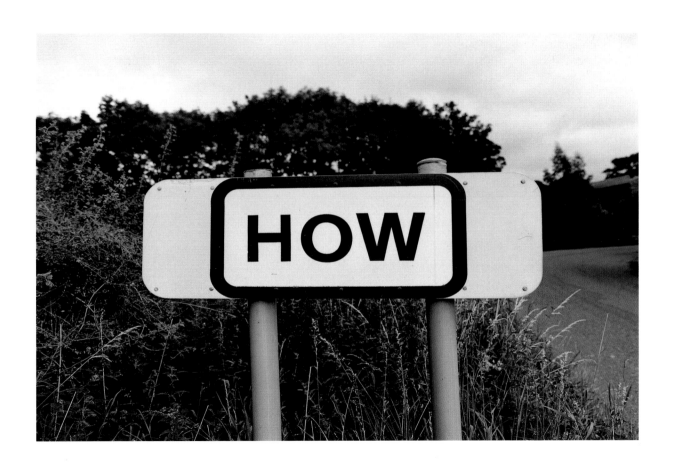

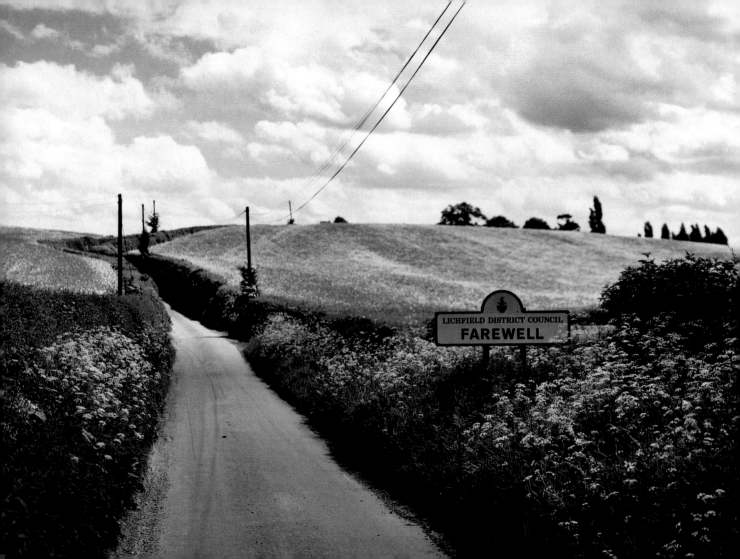

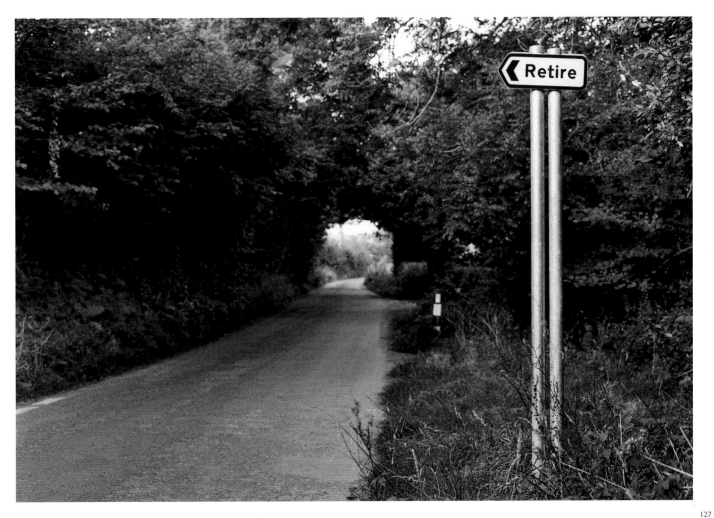

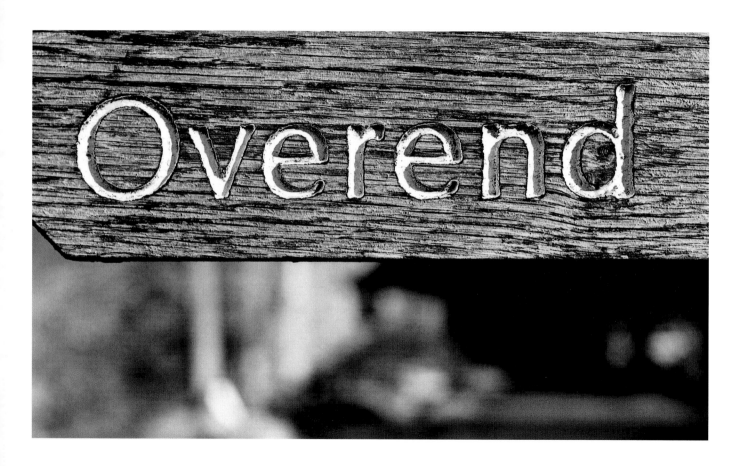

INDEX AND ETYMOLOGY

Cold Christmas, Hertfordshire 7

Noted as Cold Christmas Field in 1840; one of a range of derogatory field-names that refer to poorly yielding land (see Labour-in-Vain Hill)

Coldrain, Perth & Kinross 87

Probably 'thorn wood' or 'thorn nook', from Gaelic *coil*, 'wood', or *cuil*, 'nook', plus *draighionn,* 'thorn'

Coven, Staffordshire 85

Probably from Old English *cofa*, 'a chest, chamber', referring to the rounded oven used here for charcoal-making from medieval times

Cow Roast, Hertfordshire 34

The local inn was called Cow Rest; situated on a drove road, it apparently had extensive pens for housing cattle on the way to London markets.

Crabstack, Cumbria 81

First recorded at the end of the 16th century, this name probably derives from Middle English *crabbe*, 'a crab-apple tree', plus 'stack' from Old Norse *stakkr*, 'a (hay)stack' – hence 'rocky stack by the crab-apple tree'

Crackpot, North Yorkshire 40

From Old Norse *kraka*, 'crows' and Middle English *potte*, 'rocky cleft' – hence 'Rocky cleft where crows abound'

Cuckoo's Knob, Wiltshire 123

No early references, so probably 'hillock frequented by cuckoos'

Cults, Aberdeenshire 41

From Gaelic *cùillte*, 'place in the nook' . The s is probably an English plural

Curry Mallet, Somerset 19

Close to the river Curry, possibly a Celtic name meaning 'border, boundary'; the local manor was owned in the 12th century by a William Malet

Dallas, Moray 35

Possibly from early Celtic *dol*, 'meadow' and *foss*, 'place surrounded by a ditch'

Dancing Dick's, Essex 122

Combines the Middle English 'dancing' with Old English *dic*, 'ditch', signifying a 'field with boundary ditches used for dances'

Dawn, Conwy 121

Welsh *dawn* means 'gift, donation'; this may have been an estate given to a person or religious body (see Oath)

Deer, Old and New, Aberdeenshire 113

From Gaelic *doire*, 'forest'; The division into *old* and *new* is post-medieval

Discoed, Powys, Wales 12

From Old English *dic*, 'ditch, dike', plus *cot*, 'cottage' – hence 'cottage(s) by Offa's Dike'; now transformed into Welsh *dis*,

'under', and *coed*, 'wood' – hence 'place under the wood'

Dog Village, Devon 44

Modern name, probably self-explanatory, ie 'village known for its dogs'

Drinker's End, Worcestershire 64

Area of the village or estate owned or occupied by the Drinker (formerly *Drynkar*) family, known here from 1297; end derives from Old English *ende,* 'area, district'

Drugger's End, Worcestershire 65

No early references, so probably a modern name referring to a local family or, imaginably, an apothecary

Dufftown, Moray 8

Named after James Duff, 4th Earl of Fife (1776–1857), who founded the town in 1817

Dull, Perth & Kinross 6

From Gaelic *dail*, 'a plain, a meadow'

Each End, Kent 67

From Old English *hæcc*, 'hatch, gate', plus 'end'

Edendork, Co. Tyrone 38

From Irish *Éadan na dTorc* meaning 'hill-face of the pigs'

Everland, Fetlar, Shetland 49

From Shetland Norn (a local dialect) *ofri*, 'upper, higher', plus *land*, 'arable field', meaning 'Upper field'

Farewell, Staffordshire 126

'Place by the pleasant stream', from Old English *fæger* meaning 'fair' or 'pleasant' and *wella*, 'spring' or 'stream'

Fearnan, Perth & Kinross 24

From Gaelic *fearna*, 'an alder tree'

Foulness, Essex 91

'Bird promontory', from Old English *fugol*, 'bird, fowl', plus *næss*, 'headland' or 'promontory'; first recorded in the 12th century

Fryup, North Yorkshire 2, 3

Possibly derives from the Old English name *Friga*, followed by *hop*, 'remote valley' – hence 'Friga's valley'

Furnace, Argyll & Bute 83

From Gaelic *fuirneis*, 'furnace', indicating the site of an old iron-works

Gasper, Wiltshire 107

First recorded as *Gayespore* in 1280; the second syllable stems from Old English *spora*, 'hill-spur'; *Gaye* is probably a personal name

Giggleswick, North Yorkshire 27

Possibly from the old English name *Gikel* and *wic*, a 'dwelling' or 'specialised farm' – hence Gikel's farm

Ginge, Oxfordshire 88

Name is shared with nearby Ginge brook, which is from Old English *gægian*, 'to turn', and refers to the winding river

Golly, Wrexham 26

Possibly from the Welsh *y gollen*, 'the hazel tree', or a site associated with St Collen (the lack of the customary *llan*, 'church', makes the latter less likely)

Good Easter, Essex 39

From the Old English woman's name *Godgyth* or *Godgifu* and *eowestre* meaning 'sheepfold'

Hard Hills, Cumbria 57

From Old English *heard* meaning 'hard' in the sense of 'frightening, dismal'

Hexworthy, Cornwall 82

First recorded in 1317 as *Hextenesworth*; This stems from the Old English man's name *Heahstan* plus *worthig*, 'enclosure – hence 'Heahstan's enclosure'

High Ham, Somerset 32

From Old English *hamm* meaning 'land in a river bend'; High and Low Ham are in a wide bend in the river Parrett

Hints, Shropshire 54

First recorded in 1242, this stems from a Celtic word *hint* meaning 'a path, a road'

Homer, Shropshire 16

From Old English *hol*, 'hollow', plus *mere*, 'pool' – hence 'pool in a hollow'

Horsey, Norfolk 28

'Raised land grazed by horses', from Old English *hors*, 'horse', plus *eg*, 'island, raised land' (the land here is coastal marshland, and the horses were most likely wild)

How, Cumbria 125

From Middle English *howe* meaning 'hill'; first recorded in 1610

Inkerman, Durham 75

Named after the Crimean Battle of Inkerman, November 1854

Inner and Outer Hope, Devon 15

A small enclosed valley or secluded spot from Old English *hop*, here referring to the sea cove

Keith, Moray 9

From early Celtic *ced*, 'a wood'

Labour-in-Vain-Hill, Wiltshire 106

A derogatory name referring to the low yield of a hill (see Cold Christmas)

Laid, Highland 110

Original Gaelic word meaning 'pool, watercourse'

Land of Nod, East Riding, Yorkshire 102

In the Bible this was where Cain was exiled after killing his brother Abel, so presumably derogatory or indicating remoteness (see California and Palestine)

Letters, Highland 74

From Gaelic *leitir*, 'land on a slope'

Littleness, Shetland
From Old Norse *litill* as in 'small' and *nes*, 'headland, promontory'

Loanends, Co. Antrim
'Lane-ends', from Middle English via Scots *loan* (English *lane*) plus *ends*; several minor roadways converge here

London Apprentice, Cornwall
Precise origin unknown but likely to derive from a modern pub name

Lover, Wiltshire
May well be a modern designation, perhaps from a surname; early source could be Old English *læfer*, 'reed bed'

Lower Slaughter, Gloucestershire
From Old English *slohtre* related to 'slough'– hence 'Lower muddy place'; first recorded in 1317

Macaroni Woods, Gloucestershire
Modern name; significance unclear, possibly a surname

Mail, Shetland
Exact origin unknown but may be from Gaelic *maol*, 'a bare, rounded hill' (a hill rises behind the hamlet)

Mavis Grind, Shetland
In Norn, the local Shetland dialect, *grind* is a gate; presumably refers to the strip of land separating the Atlantic from the North sea here; Mavis may be the name of the landowner

Merrylands, Somerset
'Land by a boundary', from Old English *gemære*, 'boundary', and *land*, 'land, usually arable recently ploughed from waste'

Mid Yell, Yell, Shetland
Yell, the name of the island, is from Old Norse *gelld*, 'barren'; Mid Yell is exactly at the mid-point of the island north to south

Minions, Cornwall
Village named in 1897 after a bronze-age barrow, *Minnions Burroughe* meaning 'Minions Mound'; derivation of Minions unknown

Moans Cross, Co. Fermanagh
Possibly from Irish *móin*, 'bog', plus *crois* meaning 'crossroads' – hence 'bog crossroads'

Moneydig, Co. Londonderry
Probably from Irish *muine*, 'thicket, grove'; last syllable may derive from *teac*, 'house', leading to 'house by the grove'

More, Shropshire
From Old English *mor*, 'waste or swampy land'

Morebattle, Scottish Borders
From Old English *mere-botl*, 'house by a lake'

Mucking, Thurrock
'The area occupied by the *Muccingas*', another Old English clan or tribal name

Nasty, Hertfordshire
First recorded as *Nasthey* in 1294, from the Middle English phrase *atten ast hey*, '(place) at the east enclosure'

Netherthong, West Yorkshire
From Old English *thwang*, 'a strap or strip' and *neothera* or Middle English *nether*, which refers to the land connecting this village with Upperthong

New Invention, Shropshire
Most likely refers to the bellows powered by a water wheel that was installed in a local forge; the name may have transferred from an inn sign to the village.

Nobottle, Northamptonshire
'New building' from Old English *niwe*, 'new', plus *bothl*, 'building', first recorded in Domesday Book (1086)

No Place, Co. Durham
May be similar to 'No Man's Land', meaning land not owned by any individual, or could refer to its remoteness

Oath, Somerset
A dialect spelling/pronunciation *Wooth* is known; possibly an estate given to a person or religious body in fulfilment of a vow or oath

Octon, East Riding of Yorkshire
'Occa's farm', Old English personal name with *tun*, 'farm estate'

Odder, Lincolnshire 124
Possibly 'Odda's riverbank settlement', from Old English personal name *Odda* plus *ofer*, 'river bank'

Ogle, Northumberland 55
Known at one time as *Hoghill*, Ogle was named after Ocga, son of King Ida (reigned 547-568), plus Old English *hyll* – hence 'Ocga's Hill'

Old, Northamptonshire 60
From Old English *wald*, 'forest'

Overend, Worcestershire 128
Probably 'end of the ridge', from Old English *ofer*, 'ridge' and *ende*, '(area at the) end'

Over Wallop, Hampshire 30
Possibly 'valley of the stream', from Old English *wella*, 'spring' or 'stream', plus *hop* meaning 'remote valley'

Palestine, Hampshire 61
Biblical name, probably signifying the village's remoteness (ie 'a place as far away as Palestine')

Pant, Shropshire 99
Known earlier as *Pant Trystan* from Welsh *pant*, 'valley', and personal name Tristan

Pill, North Somerset 97
From Old English *pyll* meaning 'creek' or 'pool'

Pity Me, Durham 25
A humorous term for a barren or desolate piece of land, first recorded in 1862

Reach, Cambridgeshire 36
From Old English *ræc* '(place on a) raised strip of land'; the village stands on the northern tip of the post-Roman earthwork known as Devil's Dyke

Retire, Cornwall 127
From Cornish *rid*, 'a ford', and *hyr* meaning 'long' – hence 'long ford'

Ripe, East Sussex 46
From Old English *ripp*, 'a strip', referring to a narrow band of land or a ridge; first recorded in Domesday Book (1086)

Rock, Co. Tyrone 50
From Modern English 'rock'; there is an outcrop of rock here

Ruffside, Co. Durham 117
Recorded as *Rugeside* (1363), from Old English *ruh*, 'rough, uncultivated', and side, 'hillside' – hence 'rough hillside'

Seething, Norfolk 116
Recorded as *Sithinges* (1086), probably '(settlement of) the family or followers of a man called *Sitha*'

Sexhow, North Yorkshire 98
From Old Norse male name *Sekkr* with *haugr*, 'mound', meaning 'Sekkr's mound'

Six Mile Bottom, Cambridgeshire 109
Refers to the fact that the village lies in a hollow six miles from Newmarket

Skinburness, Cumbria 79
The early spelling *Skyneburg* may be a Scandinavianised form of Old English *scinnan burg* meaning 'haunted castle' with *ness*, 'headland'

Soar, Anglesey 52
Celtic or pre-Celtic river name meaning 'flowing one'

Souldrop, Bedfordshire 14
Recorded as *Sultrop* (1196), from Old English *sulh*, 'gully', plus *throp*, 'outlying farm', meaning 'outlying farmstead near a gully'

Sound, Shetland 51
From Old Norse *sund*, 'a sound, a sea-passage between land-masses'

Start, Devon 5
From Old English *steorte*, 'tail' or 'promontory'

Stepaside, Powys 62
Refers to a narrow bridge where one person has to 'step aside' if another is crossing at the same time

Stove, Unst, Shetland 78
From Old Norse *stofa*, 'sitting room, house'; several farms in Shetland have this name

Swine, East Riding, Yorkshire 94
From Old English *swin*, 'a creek', first recorded in the 12th century

Swordly, Highland, Scotland 63
May derive from Old Norse *svörth*, 'grassy spot'

Tempo, Co. Fermanagh 53
Reduction of the Gaelic phrase *an tIompú Deiseal*, 'the right-hand turning', possibly referring to a clockwise turning in (pre-Christian) worship

Thwing, East Riding of Yorkshire 17
A long ridge, Old Norse *thvengr*, 'a thong, a strap'; the Old English form of the word is found in Netherthong

Tiptoe, Northumberland 103
From Old English *æt-yppe-hoh* meaning '(place) at the high hill spur'

Tongue, Highland 96
From Old Norse *tunga*, 'a tongue, spit of land'

Trevor, Wrexham 93
Possibly from Welsh *tref*, 'farm' with *mawr* 'big'; there are several places with this name

Twatt, Orkney 10
From Old Norse *thveit*, 'cleared place'

Updown, Kent 66
'Up a hill, up on the downs' from Old English *up*, 'up' with *dun*, 'hill, downland'

Ventongimps, Cornwall 92
Cornish *fenten*, 'spring' (derived from the Latin *fons* meaning a 'well' or 'natural spring'), with *compes*, 'even', meaning 'steadily-flowing spring'

The Wart, Shetland 115
From Old Norse *vartha*, 'a heap of stones'

Wendy, Cambridgeshire 112
From Old English *wende*, 'bend', with *eg* 'island' – hence 'island at the river bend'; Wendy lies on a bend of the North Ditch near its confluence with the River Cam or Rhee

Wham, North Yorkshire 77
From Old Norse *hvammr*, meaning 'marshy hollow'

Wideopen, Tyne & Wear 58
A modern mining village in an exposed location, 'wide open' to the elements

Wigwig, Shropshire 16
From Old English personal name *Wicga* plus *wic*, 'specialised farm' – here most likely a dairy farm, so 'Wicga's dairy farm'

Womenswold, Kent 84
'Forest of Wimel's people' from Old English *Wimlingas*, 'Wimmel's family or followers' with *wald* 'forest'

Worth, Kent 70
From Old English *worth*, 'an enclosure'

AFTERWORD

Unusual place names have appeared as, well, landmarks throughout my life. My childhood holidays revolved around the Cumbrian hamlet of Boot and, later on, a road trip around Denmark took me past a sign for the town of Middelfart. I'm afraid to say that the inevitable happened: I was photographed in front of the sign, bending over, thus neatly blocking out the first two syllables. I'm sure you can appreciate the immense hilarity this provided a nearly-teenager.

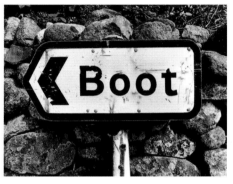

The job, with a transport consultancy, involved calculating the distance of a long list of British villages from their nearest train stations. My attention, however, was soon diverted by such ridiculous names as Wigwig, Pity Me and Ventongimps, and I became absorbed in compiling an alternative list. The effort got me demoted to counting passengers on and off the W7 bus, but at least the germ of a project had formed in my mind. I would tour Britain, photographing every absurdly incongruous place name I could track down.

Years pass by and so do the road signs. A fan of Spike Milligan, I started looking at passing town and village names from a Milliganesque point of view. If a place like Bexhill-on-Sea could be linked to names like Eccles and Bluebottle, then imagine what could be done with Curry Mallet...

These were just idle thoughts, though, to while away boring car journeys. It took a holiday job, at the end of a Film and Photography degree, to give these musings a more practical turn.

I didn't, at least not then. Instead, I worked for the next five years in a film studio as part of the camera crew, making music promos for artists such as Blur, Pulp and Fatboy Slim.

It was the perfect job for a music fan like myself – but it couldn't last. When the studio closed, I once more became master of my own destiny. I turned freelance. And so it was, en route to a short film location in Powys, that I detoured to take

in two places I'd noticed on the map. One was called Discoed, which I presumed was a retirement village for jaded ravers, and the other New Invention. I captured both signs on colour 35mm, using my trusty Nikon.

New Invention particularly intrigued me. Not only did the warning triangle indicate a sharp right-hander whilst the road disappeared to the left, but the huge 'SLOW' painted in the road seemed to suggest an anxiety about what the invention might be. As I didn't want to infer it was a speeding transit van or Robin Reliant, I waited for the traffic to clear.

An impending wedding propelled me on an expedition to the Sussex village of Cocking, which happened to be the surname of my pal getting married. By now I'd decided that black and white was the way forward for the signposts. Colour, I felt, distracted the eye, and I wanted the viewer to focus on the words rather than be seduced by the saturated hues of the British countryside. The print seemed to have a profound effect on Ben, who now lectures in semiotics and has the print hanging in his office.

A long stint working on *Lesser-Spotted Britain* for Channel Four and the spoof 1970's educational programme *Look Around You* for BBC2 gave me the money to embark on my long-delayed road trip. I hired a medium format camera, a Mamiya RZ67, packed the Cinquecento (possibly the ultimate in long-distance driving – if not sleeping – comfort), and got down to business.

For old times' sake I started with Boot; but the first real step into uncharted territory was Scotland. Within a matter of days Dull, Dufftown, Boreland and Keith were in the bag. I even travelled all the way to Orkney in search of the elusive Twatt. I remember staring disconsolately at a wrought-iron gate proudly proclaiming 'Twatt Farm Millennium 2000' – the closest thing to a village sign that I could find after arriving on a dawn ferry. Driving back I had a sudden revelation: the road sign pointing the way would do just as well.

Over the following couple of years I took more trips, between freelance TV and photography projects. Invites to far-flung weddings or parties were accepted with enthusiasm, after I'd pored over local maps, and I got to see most of my old friends who had dispersed around the country. The boundaries of the project, however, remained the further reaches of Britain and Northern Ireland, as I realised that I was pursuing a peculiarly quirky, lopsided representation of these sceptred isles.

And how does the tale end? Well here's the collection, my own top choices out of more than two hundred photos, and there are still those places at large that the elements prevented me from photographing (hey, this is Britain!). The journey, too, has come almost full circle. This year I'm getting married to Alison Overend. Where? Boot, of course.

Dominic Greyer
Stoke Newington, 2004

ACKNOWLEDGEMENTS

A big thank you to Nat and Mark at Sort Of for their vision and enthusiasm; Matt Wilson for expert printing and dedication above and beyond; and to Peter Dyer, Tim Chester, Paul Cavill, Dominic Beddow, Miranda Davies and Henry Iles for exemplary design, production, etymologies, map-making and layout.

Thanks also to: Rob Deering, Fraser Bensted, Gary Driver, Lucy Riches, Avalon TV, Paul Barton, Steve Fairweather, Simon Davis, Alex Walker, Dennis Henry; Deke, John and The Three Kings; Crispin and Zoo Books; John, formerly of *The Tup*, Stoke Newington; Gill Preater for donating 'the fox', and John Francis at George's Garage, for keeping it on the road; and to all the family and friends whose beds and floors I've slept on during the project: Alan and Jenny; Alex and Caroline; Ben and Emily; Derek; George; June; Justin, Kirsty and Ossian; Lorna; Nic and Helen; Robin and Sarah; Simon, Brad, Lou and Archie; Victor and Olive; Maggie, Marianne and Bent for the Danish road trip.

Special thanks to Emily Cocking who got me into the right place at the right time; to my parents, Fred and Joan, and brother Jim for the happy memories of steam trains, fell walking and kendal mint cake; and to Alison for the love, support and motivation – it's amazing what a night out at *The Criterion* can help achieve!

The travel for this book was undertaken **without** the help of Esso fuels – see *www.stopesso.com*

The etymologies were compiled with the help of Dr Paul Cavill of the English Place-Name Society, School of English, University of Nottingham, NG7 2RD.

Cover design © Peter Dyer
Maps © Draughtsman Ltd 2004
Photos printed by Matt Wilson Labs, London E8
Origination by Dot Gradations Ltd, Wickford, UK
Page Design by Henry Iles
Published in 2004 by Sort of Books, PO Box 18678, London NW3 2FL. www.sortof.co.uk
Distributed by the Penguin Group in all territories excluding the United States and Canada: Penguin Books, 80 Strand, London WC2R ORL.
Printed in Italy by Printer Trento S.r.l.
A catalogue record for this book is available from the British Library.
ISBN 0-9542217-7-X [144pp]

FOR MY PARENTS, NAN, BROTHER

AND ALISON

PEMBROKESHIRE

CARMARTHENSHIRE

POWYS

HEREFORDSHIRE

BETHLEHEM

WALES

DRINKER'S END

LOWER SLAUGHTER

GLOUCESTERSHIRE

MACARONI WOODS

PILL

LABOUR-IN-VAIN HILL

CLENCH
CUCKOO'S KNOB

WILTSHIRE

SOMERSET

GASPER

HIGH HAM
BEER
OATH

MERRYLANDS

LOVER

CATSGORE

CURRY MALLET

ENGLAND

DORSET

PLUSH

DEVON

DOG VILLAGE

HEXWORTHY

CHIPSHOP

MINIONS

AMY TREE

RETIRE

START

VENTONGIMPS

LONDON APPRENTICE

INNER & OUTER HOPE

CORNWALL

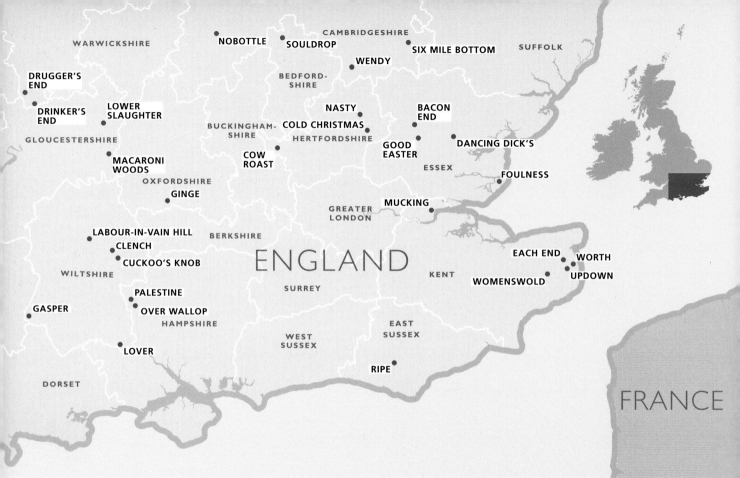

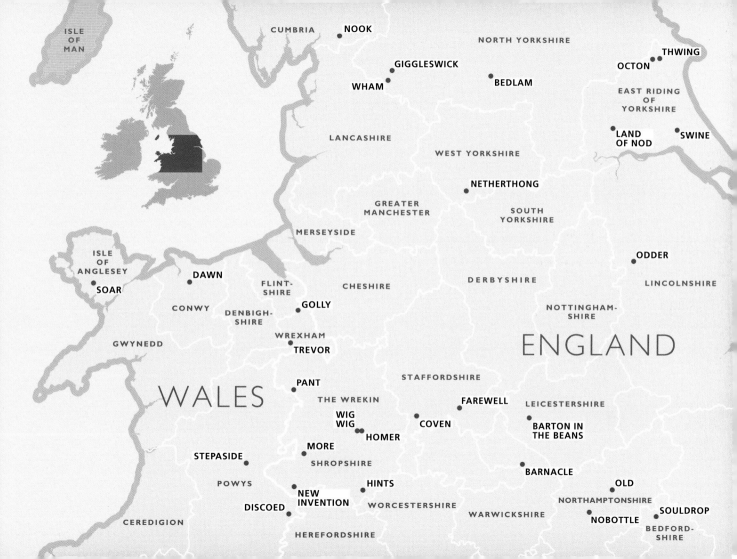

SCOTLAND

IRELAND

DONEGAL

MONEYDIG

LONDONDERRY

ANTRIM

NORTHERN IRELAND

TYRONE

LOANENDS

ROCK

LACK

CARLAND EDENDORK

TEMPO

BLEARY

MOANS CROSS

DOWN

FERMANAGH

ARMAGH

CLONES

BRIGHT

MONAGHAN

CAVAN

THWING
OCTON

SWINE

LINCOLNSHIRE

HORSEY

NORFOLK CALIFORNIA

ENGLAND

SEETHING

CAMBRIDGESHIRE

REACH

SUFFOLK

SOULDROP

SIX MILE BOTTOM

WENDY

ARGYLL & BUTE

PERTHSHIRE & KINROSS

FIFE

STIRLING

FURNACE

COLDRAIN

FALKIRK

WEST LOTHIAN

EDINBURGH

EAST LOTHIAN

MIDLOTHIAN

NORTH AYRSHIRE

SOUTH LANARKSHIRE

BORDERS

TIPTOE

ARRAN

EAST AYRSHIRE

MOREBATTLE

SCOTLAND

SOUTH AYRSHIRE

NORTHUMBERLAND

BORELAND

OGLE

DUMFRIES & GALLOWAY

ENGLAND

WIDE OPEN

TYNE & WEAR

HOW

NO PLACE

SKINBURNESS

RUFFSIDE

PITY ME

INKERMAN

DURHAM

CRABSTACK

CUMBRIA

HARD HILLS

OVEREND

SEXHOW

FRYUP

BOOT

CRACKPOT

NORTH YORKSHIRE

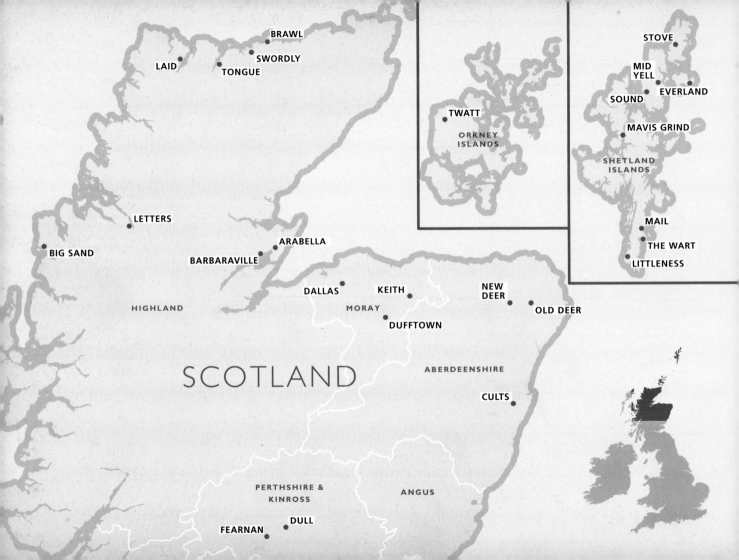